IMAGES
of America

SOUTH
SAN FRANCISCO

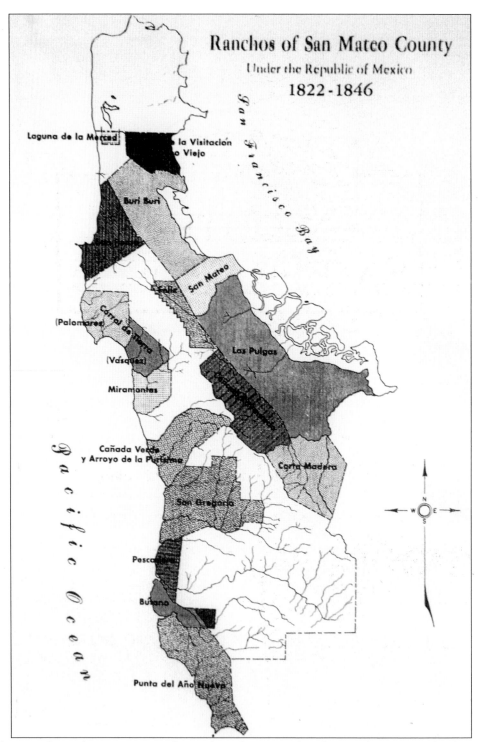

Ranchos of San Mateo County

Under the Republic of Mexico

1822-1846

San Francisco Bay

Pacific Ocean

Laguna de la Merced

...la Visitación
...o Viejo

Buri Buri

San Mateo

E. Feliz

(Palomares)

Corral de Tierra

(Vásquez)

Miramontes

Las Pulgas

Cañada Verde
y Arroyo de la Purísima

Corte Madera

San Gregorio

Pescadero

Butano

Punta del Año Nuevo

This map shows the numerous rancheros along the Peninsula. The Rancho Buri Buri land grant consisted of 14,639.19 acres and was owned by Don Jose Antonio Sanchez from 1836 until his death in 1843. (Courtesy of South San Francisco Historical Society.)

IMAGES
of America

SOUTH
SAN FRANCISCO

South San Francisco Historical Society

ARCADIA

Published by Arcadia Publishing
Charleston SC, Chicago IL, Portsmouth NH, San Francisco CA

Printed in Great Britain

Library of Congress Catalog Card Number: 2004108144

For all general information contact Arcadia Publishing at:
Telephone 843-853-2070
Fax 843-853-0044
E-mail sales@arcadiapublishing.com
For customer service and orders:
Toll-Free 1-888-313-2665

Visit us on the internet at http://www.arcadiapublishing.com

Cover: Some Shaw Batcher Company employees pose *c.* 1900 inside a car that is inside a pipe. Established in 1893 in Sacramento, the plant was located on Butler Road (Oyster Point Boulevard). The South San Francisco plant was built in 1912. By 1916, Shaw Batcher was the largest pipe enterprise on the West Coast and the second largest South San Francisco iron plant. Between 1914 and 1918, ships were built at Oyster Point Channel for World War I. In June 1917, Western Pipe and Steel Company bought the plant. (Courtesy of South San Francisco Public Library Local History Collection.)

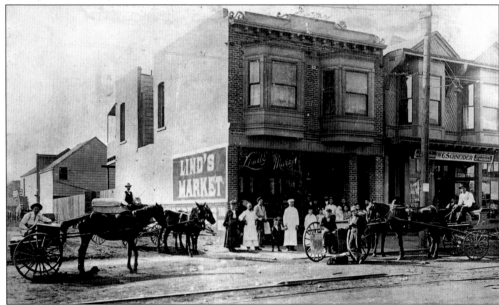

Lind's Market was established in 1905 at 221 Grand Avenue and owned by Swedish immigrant Peter Lind. This building is still standing today with a distinctive five-point tiled star on its frontage that is the trademark of Jesus Ron, bricklayer and independent worker. (Photo *c.* 1905, courtesy of South San Francisco Historical Society.)

CONTENTS

Acknowledgments 6

Introduction 7

1. Founding Fathers 9

2. Birth of Industrial City 21

3. War Years 45

4. Balanced Community 66

5. 20th-Century Leaders 91

6. Transformation to Biotech City 111

ACKNOWLEDGMENTS

If it were not for the collaborative effort and persistent force of several historical society members, this project would not have been accomplished. Special thanks from the historical society goes to the South San Francisco Public Library—in particular to Kathy Kay, whose research made the process less painful and whose personal interest was invaluable. We also thank Banny Rucker for her time and expertise. Also at the top of the list to thank is Robert Yonker, of the city's information technology department, who worked so diligently with the Society to prepare the photos for publishing. Sincere thanks to John Wong, recreation supervisor, for the thousands of pictures taken over the last 20-plus years, each one with a story. Thanks also go to Mike Lappen, senior planner, who makes it easy to capture the beauty of South San Francisco. We express our appreciation to the folks who responded to the call for submitting pictures and information: Alvaro Bettucchi, Lola Garcia, Ed Zaro, John Mascio, and Darold Fredericks. A tremendous amount of information was also provided by *South San Francisco, A History,* by Linda Kauffman, 1976. Last but not least to be thanked are the historical society folks who worked effortlessly on this group project—most importantly, Sylvia Payne, Elizabeth Ervin, and Eleonore Fourie. They pulled the pictures together and did hours of research. Sincere thanks to Frances Regalia, Phyllis Feudale, Mary Giusti, Chris Carr, Kay Stathopolos, Evelyn Martin, Bertha Iskra, and Roy Bava for their research efforts. Recognition is also due to Jackie Kious and Rick Ochsenhirt for their willingness to take on a chapter and make it work. There were many photographs that were considered and put aside, and many that were submitted after the deadline, which we said we'd save for volume two. We hope you will be able to look through these pages and see that the pictures reveal a sense of time and perhaps bring a smile and a remembrance. This book is dedicated to our founding fathers who had the wisdom and fortitude to take root here and make South San Francisco, the Industrial City, their home and the town that could.

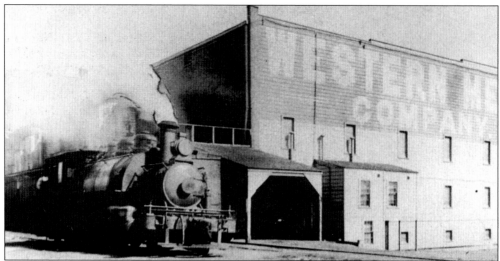

Western Meat Company's private railroad tracks were also used by the South San Francisco Railroad and Power Company to transport employees to work from Oak Avenue, down Grand Avenue ending at Point San Bruno. (Courtesy of South San Francisco Public Library Local History Collection.)

INTRODUCTION

The history of South San Francisco has all the aspects of a Western saga—Indians, a vast rancho, a cattle baron, and settlers.

More than 300 years ago, Ohlone Indians roamed the area catching fish in the bay and snaring small game in the verdant hills and valleys. A century later the Spanish explorers arrived. They gazed in awe at San Francisco Bay from a hilltop overlooking what is today South San Francisco. Their diaries tell us it was a clear, windy day—crisp, fresh, sunshine-bright. It was a fascinating panorama, and they foresaw the future—that it would be a magnificent place for ships and commerce and people.

After the Spaniards departed (and until California became a part of the United States of America) the Mexican government was in control. At that time, the Mexican government gave huge land grants to its supporters.

Señor Don Jose Antonio Sanchez was granted the vast Rancho Buri Buri on September 23, 1835. Sanchez served as a soldier for more than 30 years, and the land was a reward for his service first to Spain and then Mexico. Less than 10 years later, Sanchez died. By 1863 Sanchez's heirs (three boys and four girls) retained 14,639 acres of their father's Northern Peninsula Land Grant.

In 1853, 1,500 acres of the Rancho Buri Buri were sold by Isidro Sanchez to Alfred Edmonson, who in turn sold the property in 1856 to Charles Lux, a cattle baron. Lux and his partner Henry Miller, a Central Coast cattle rancher, fattened their cattle on an area of land they named Baden (which probably was a reference to Miller's birthplace in Germany). The Miller-Lux partnership supplied cattle to the city of San Francisco via the El Camino Real and later on barges or by railroad.

The town-site of Baden (so named until incorporated into South San Francisco in 1908) included 68 acres of land owned by Loupe & Descalso (south of Baden Station and East of Lux Ranch) and dairy farms (c. 1850–1895) including the 12-Mile Farm, J.G. Knowles's Farm, and Guadalupe and Leipsic Dairies.

Just one year later, businessmen from Chicago led by Gustavus Swift started the Western Meat Company at Point San Bruno, which was the town's first industrial development. The name of South San Francisco followed the pattern planned by Swift, as his other plants were "South Chicago" and "South Omaha."

South San Francisco started as a "company town," with W.J. Martin and E.E. Cunningham in charge of the South San Francisco Land & Improvement Company. Men who worked for W.P. Fuller Paint Company, local steel mills, brick factories, and Western Meat Company bought lots from the Land & Improvement Company and built their homes.

Early settlers included many Irish butchers from Chicago. Among them was Thomas L. Hickey, who later served as a member of the San Mateo County Board of Supervisors for several years. Today the area where the Irish settled in South San Francisco is still known as "Irish Town."

Civil government started in 1892 with druggist J.H. Hubachek as justice of the peace and J.H. Hill as constable. By 1895 there were approximately 671 residents in South San Francisco. The feisty community was beginning to flex its muscles.

W.J. Martin became president of the Citizens' Mutual Protective Association. On April 11, 1892, a post office and telephone company opened at San Bruno Road and Miller Avenue with E.E. Cunningham as postmaster and agent and later the editor/publisher of *The Enterprise*, a local newspaper that began in 1895. George Kneese opened the first grocery store in town. Henry Kneese was elected city marshal and tax collector.

Until a committee for incorporation was formed, South San Francisco Land & Improvement Company carried the financial burden of providing the town with lighting, sewer connections, water, and other necessities that were usually paid for by taxes.

Because the community was growing, founding fathers Dr. Harry Plymire, Ebenezer Cunningham, Ambrose McSweeney, Thomas Hickey, Edward Pike, J.R. Luttrell, Michael Healy, Andrew Hynding, and Thomas Connelly comprised a committee seeking incorporation. There were 14 major industries and a population of 1,989 when South San Francisco was incorporated on September 19, 1908, with Andrew Hynding as the first mayor.

Following incorporation, through both good and lean years, the town focused on survival and prospered. Early on, "The Industrial City" motto was adopted, and in 1923 the first logo was etched into the side of Sign Hill with powdered lime by members of the enthusiastic chamber of commerce. It later was made permanent with concrete letters when the chamber successfully sponsored a $5,000 bond issue in 1928.

Today, South San Francisco stretches from the foothills of the southerly slopes of the San Bruno Mountains to the boundaries of the city of San Bruno, and from the crest of Portola Ridge to the Alameda county line in San Francisco Bay.

From the Spanish land grant to the smokestack industries to the 20th-century municipality, South San Francisco retains a progressive/pugnacious profile on the peninsula—thanks to visionary leaders and sturdy settlers of diverse nationalities.

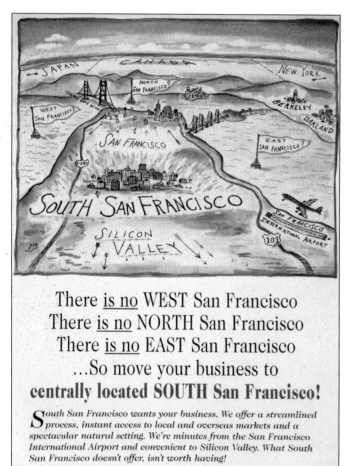

This 1999 poster, produced to attract biotech companies, is reminiscent of similar efforts in 1900 to attract heavy industry to South San Francisco. (Courtesy of City of South San Francisco.)

One

FOUNDING FATHERS

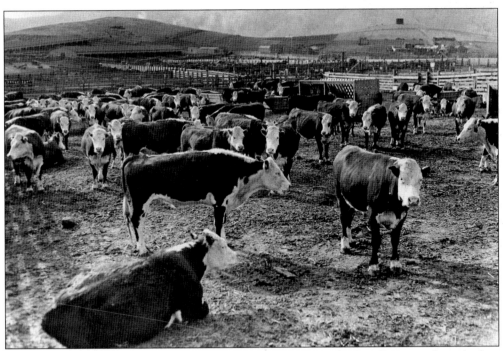

During both the Sanchez family and "Miller and Lux" era, Rancho Buri Buri served as a feeding place for hundreds of cattle that were destined for San Francisco's Butchertown, located on the Islais Creek. In 1889, shortly after Lux's death, Peter Iler, agent for Gustavus Swift of the Swift Meat Company, made a deal with Miller to incorporate his land into the South San Francisco Land & Improvement Company. This was the beginning of Industrial City. (Courtesy of the South San Francisco Public Library Local History Collection.)

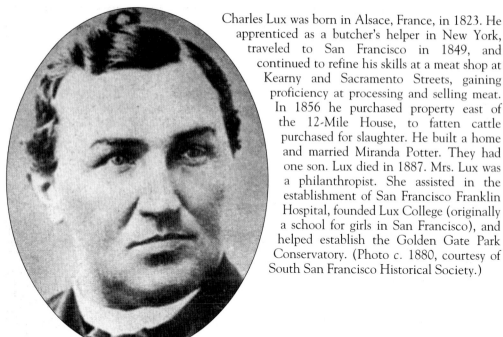

Charles Lux was born in Alsace, France, in 1823. He apprenticed as a butcher's helper in New York, traveled to San Francisco in 1849, and continued to refine his skills at a meat shop at Kearny and Sacramento Streets, gaining proficiency at processing and selling meat. In 1856 he purchased property east of the 12-Mile House, to fatten cattle purchased for slaughter. He built a home and married Miranda Potter. They had one son. Lux died in 1887. Mrs. Lux was a philanthropist. She assisted in the establishment of San Francisco Franklin Hospital, founded Lux College (originally a school for girls in San Francisco), and helped establish the Golden Gate Park Conservatory. (Photo c. 1880, courtesy of South San Francisco Historical Society.)

Cattle baron Henry Miller (immigration name Heinrich Kreiser) was born in Germany in 1827, came to America at 16 years of age, and worked as a butcher's helper in New York. The gold rush lured him to California, where he became a successful land buyer. In 1858 he formed a partnership with Charles Lux to supply cattle and meat to San Francisco. They established ranches within a day's time from each other and drove cattle up the El Camino and later used railroad and barges. The town of Baden was named after his home country. The Lux-Miller holdings were sold to the South San Francisco Land & Improvement Company in 1889, and he remained a partner. Miller was married twice. His first wife died during childbirth; his second wife was Sarah Sheldon, niece of Miranda Lux. Sarah settled at the Miller ranch in Bloomfield, south of Gilroy. Miller was said to be a stern, determined man. When he died in 1916, his fortune was valued at $50 million. (Photo c. 1880, courtesy of South San Francisco Historical Society.)

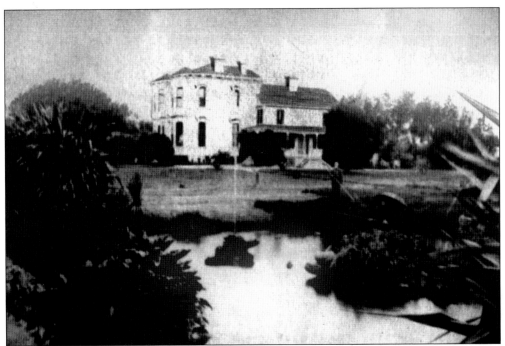

The Lux Mansion at Baden, shown in this c. 1900 photo, was built in 1858, purposely near a stream, and was the proportion of a mansion. The elaborate gardens spread out along the creek contained ornamental trees and shrubs and were adorned with statuary and garden furniture. In 1909 a barnhouse (Red Barn) was added to the property from lumber salvaged from the mansion. It was later moved to the Uccelli property. The Lux home eventually fell into disrepair. The grounds were covered over with silt from Colma Creek and the house ultimately burned down. (Courtesy of South San Francisco Historical Society.)

This is a map of the Lux property in the 1800s. (Courtesy of South San Francisco Historical Society.)

MAP OF THE LUX PROPERTY IN THE 1800'S
Site of the Lux Home in Relation to Present Streets.
Ground Level was Lower than Present and the
Creek was at Tidewater Level.

11

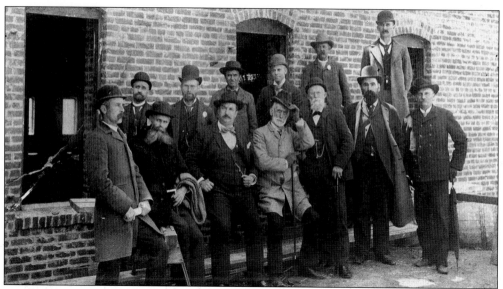

The first industrial development in South San Francisco was Western Meat Company at Point San Bruno. Gustavus Swift organized a "beef trust" with other Midwestern meat packing companies to join in building a community of stockyards and packing plants and develop an industrial town. William J. Martin, manager of South San Francisco Land & Improvement, was influential in bringing the company to South San Francisco. This 1891 photo shows Mr. Martin (extreme left front) along with the board of directors. Prominent citizens employed in founding the plant were James Carmody, foreman, meat cutting department; James Wallace, foreman, later appointed health officer and constable of the first township; Thomas L. Hickey, first foreman, killing floor; Andrew Hynding, office boy, and later purchasing agent; and Dan McSweeney, U.S. meat inspector. (Courtesy of South San Francisco Historical Society.)

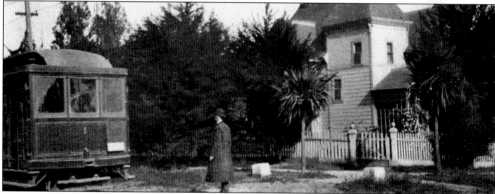

In this 1905 photo, William J. Martin is at the front gate of his home at Eucalyptus and Grand Avenues, waiting for the street car to take him to work. The home was built by Col. W.J. Rhodes & Bros. in 1898. Born in Pennsylvania in 1856, Martin attended Knox College and University and studied law and real estate. He arrived in South San Francisco in 1890, organized the South San Francisco Land & Improvement Company, and was influential in bringing industries to the area. He was considered the "father of South San Francisco," and Mrs. Marianne Martin was referred to as the "mother of South San Francisco." She was a founding member and first president of the women's club and helped establish Grace Episcopal Church. The Martin family included three children, John, David and Grace Martin Barton. (Courtesy of South San Francisco Public Library Local History Collection.)

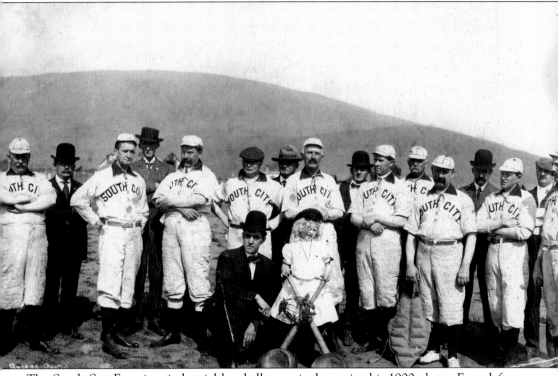

The South San Francisco industrial baseball team is shown in this 1900 photo. From left to right are (standing) J. Eikerenkotter, Dan McSweeney, George Chapman, Andrew Hynding, E.I. Woodman, Ambrose McSweeney, Judge Reyberg, William J. Martin, Coghlin, Fred Cunnhingham, unidentified, E.W. Langenbach, Dr. Harry Plymire, Thomas Mason, N. Cohen, and Tom Connelly; (kneeling) J.B. Debenedetti and Vivian Langenbach. (Courtesy of South San Francisco Historical Society.)

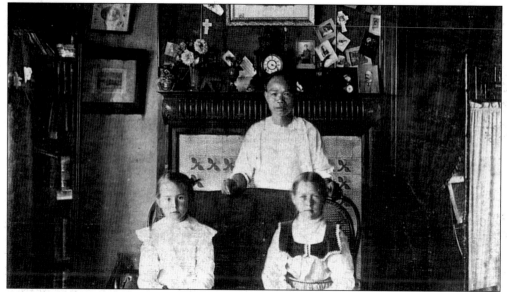

In this 1899 photo, Emma Eikerenkotter and Grace Martin are shown in the Martin home at 800 Grand Avenue, along with Martin's house servant Soong. Emma was the daughter of pioneer residents Alice and Julius Eikerenkotter, who arrived in South San Francisco in 1893 and lived at 219 Spruce Avenue. Eikerenkotter opened the town's first general merchandizing business at the Merriam Block. In 1914 he started an ice cream parlor on the corner of Grand and Linden Avenue. The Eikerenkotter family included two other daughters, Lena and Beatrice. (Courtesy of South San Francisco Historical Society.)

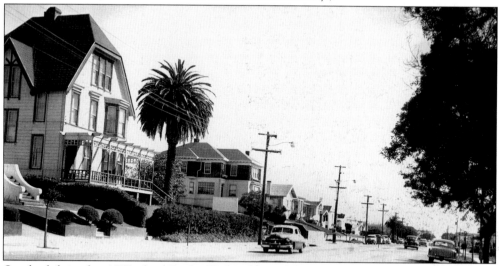

On the left in this 1950 photo is the Hickey home at 800 Grand Avenue, built in 1890 by architect-builder Herbert Maggs. On the right at 798 Grand Avenue is the home of Dr. John C. McGovern, the town dentist who arrived in South San Francisco in 1905. McGovern served on the South San Francisco Board of Trustees, was county health officer and later coroner, and president of the chamber of commerce. He was known to visit the public schools and clean the children's teeth. He co-founded the community chest and was chairman of the World War II draft board. The homes were situated at an intersection known as the Big Four-Hickey, McGovern, Martin, and McSweeney. (Courtesy of South San Francisco Historical Society.)

In 1892 at 21 years of age, Tom Hickey arrived from Chicago. Shown in this 1940 photo, he worked as foreman of the killing floor at Western Meat Company until 1907. Allegedly, he was rather good at his job and wielded the skinner's knife with the skill of a surgeon. Although a self-made man, he valued education. He was elected county supervisor in 1916 and re-elected in 1940. The modernization of El Camino is one of his achievements, and Hickey Boulevard is named after him. He fought hard for issues he believed in, including an end to corrupt government. He was one of the promoters for the Cow Palace and was known as the "father of Memorial Park" and "father of the county hospital." (Courtesy of South San Francisco Historical Society.)

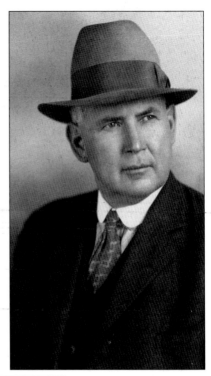

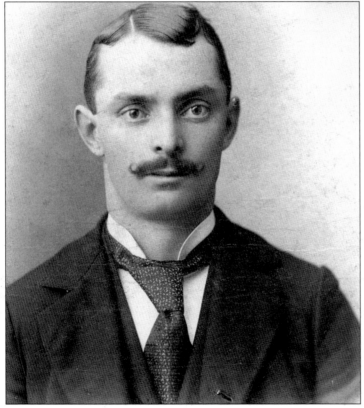

Joseph P. Quinlan was born in Half Moon Bay and came to South San Francisco in 1918 as an employee of Pacific Coast Steel. He later worked for North American Loan Company as chief accountant. He served as mayor from 1930 to 1934. In 1935 he was appointed postmaster, an office he held until 1950. He and wife Annie made their home on Lux Avenue with their children Ray, Georgette, Florence, and Gerald. (Courtesy of South San Francisco Historical Society.)

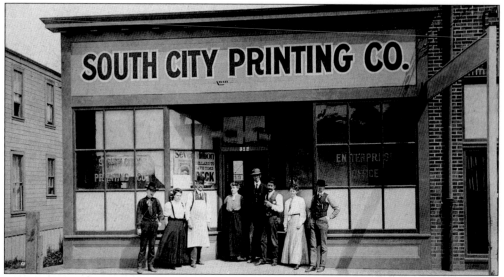

In 1895 South City Printing Company, shown in this 1900 photo, began publishing *The Enterprise* under management of Ebenezer E. Cunningham and William J. Martin. Cunningham came to South San Francisco in 1890. He was a notary public, justice of the peace (1893) and postmaster (1906–1930). In 1927, the *South San Francisco Journal* bought *The Enterprise*. In 1936, the *Enterprise Journal* was incorporated as the Industrial City Publishing Company (It should be noted that South San Francisco's first newspaper was *The News*, (1892–1893) owned by Barnes and Murphy.) (Courtesy of South San Francisco Public Library Local History Collection.)

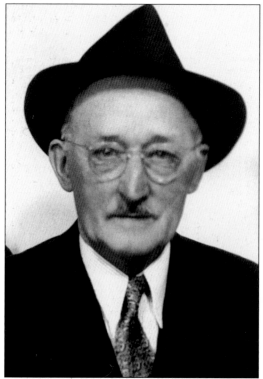

Pictured in this 1937 photo, Andrew Hynding arrived in South San Francisco in 1893 and worked as an office boy at Western Meats, earning $1.25 a week. He was promoted to purchasing agent in 1903 and stayed with Western Meats for 25 years. When the city was incorporated in 1908 he became the first mayor (one term) and was elected councilman in 1927 (one term). He remained active in civic affairs, was on the board of directors for several institutions, including the Bank of South San Francisco, South San Francisco Hospital, the Land & Improvement Company, and the chamber of commerce. He purchased the real estate company of the late Fred Cunningham and remained a businessman until his death in 1950. (Courtesy of South San Francisco Public Library Local History Collection.)

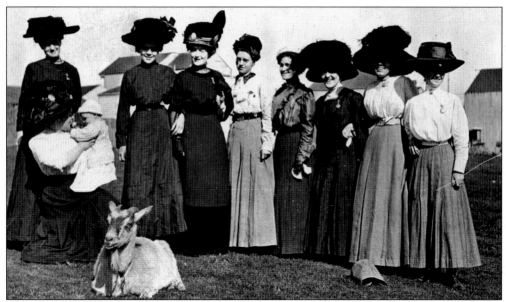

The Violet Club was a social club organized in 1911 for wives of prominent men in the community. Shown in this *c.* 1911 photo, from left to right, are (kneeling, holding Gracie Eschelbach) LaVerne Hickey; (standing) Mary Eschelbach, Josie Sands, Mary Farrell, Charlotte Davis, Luela Lane, Frances Suza, Hazel Dean, and Elizabeth McDonald. Mary Eschelbach came to South San Francisco from Dublin, Ireland, and married Albert Eschelbach in 1909. He served as councilman and mayor in 1927 and 1938. Their family included four children, Grace, Evelyn, Donald, and Eleanor. Mary worked at W.P. Fuller and the post office for a period of time. During World War II, she served on the ration board and was the recipient of several awards for her work, including recognition from the American National Red Cross. (Courtesy of South San Francisco Historical Society.)

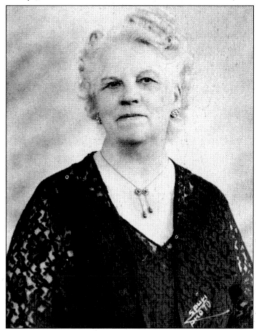

Mrs. Catherine Peck, shown in this *c.* 1930 photo, was co-founder of the Community Chest (predecessor to United Way). She and husband Edward Peck, a realtor, were most active in St. Paul's Methodist Church and donated many volunteer hours during the Depression to keep its doors open. The Pecks came to South San Francisco in 1917 when he was hired by the Land & Improvement Company to work with the J. Dunn Real Estate sub-agency. Mr. Peck was given city approval to sell lots in the northern part of the city, known today as Peck's Lot. Their residence at 210 Eucalyptus Avenue remains one of the city's most attractive homes. (Courtesy of South San Francisco Historical Society.)

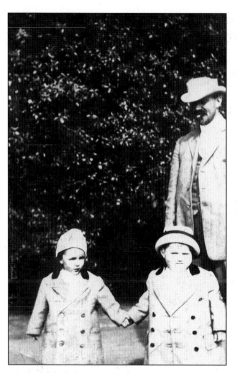

Dr. Harry Plymire, with his son Harry Plymire Jr. and Marguerite Cavassa, are shown in this 1910 photo. In 1900, Dr. Plymire arrived in South San Francisco from West Virginia. His office was in the Martin Building until 1906. He then partnered with his brother Bradley, also a surgeon, at 401–403 Grand Avenue. In the meantime, South San Francisco General Hospital was being built right up the street, to serve a rapidly growing need for industrial and private patients. Dr. Plymire was very active in civic affairs and served on the city incorporation committee. He also served as San Mateo County coroner and on the South San Francisco Board of Health. Upon his death, his business and facility was sold to Dr. Frank Dolley for $10,000. (Courtesy of South San Francisco Historical Society.)

Harry A. Cavassa, shown in this 1920 photo, arrived in South San Francisco from Bologna, Italy, in 1900. He became a protégé of Dr. Harry Plymire and received his degree in pharmacology from the University of California in 1904. He opened his first office at Grand and Linden Avenues (Martin Building). He married Lillian Hofers, a nurse at the Plymire Hospital, and became influential in the community. He was called upon to structure several fraternal organizations and aided in the development of a junior college. The Cavassas built their home at Baden and Spruce Avenues (still standing) in 1908 and had three daughters, Margherite, Marian, and Harriet (all educators). They played an important part in the 1918 flu epidemic—with their medical knowledge they were able to alleviate much of the suffering of the citizenry. Cavassa's pharmacy employees included Angelo Scampini, Frank Robinson, Jack Hickey, Charles Sellick, and Adolph Sani. (Courtesy of South San Francisco Historical Society.)

Dr. Frank Stephen Dolley, successor to Dr. Plymire, graduated from Maine's Bowdoin Medical College and was a former assistant to Dr. Stanley Stillman of Stanford University. In South San Francisco he formed a corporation for a new hospital at 500 Grand Avenue that was completed in 1918. Dr. Dolley specialized in thoracic surgery, and factory workers were a top priority. Health plans were made available at $1 a month per employee. His interest in the hospital was sold to Dr. Edwin Bartlett and assistants in 1925. Here he is shown in a c. 1940 photo. (Courtesy of South San Francisco Historical Society.)

Dr. Edwin Ichabod Bartlett, shown in this 1950 photo, graduated from Johns Hopkins Medical School and was president, superintendent, and chief surgeon at South San Francisco General Hospital from 1925 to 1946. He specialized in diseases of the breast and bone tumors. His emphasis was on industrial workers. His worked spanned the period of post–World War I prosperity, the Great Depression, and the defense-generated expansion of industry during World War II. He retired in 1946, selling his interest to Dr. Thomas Mac Veagh. His principal partners were Drs. W. J. Musselman (1930) and Maurice Olina (1935). (Courtesy of South San Francisco Historical Society.)

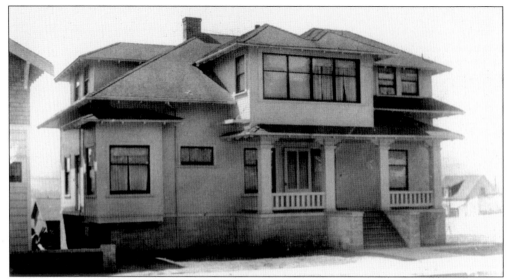

The South San Francisco General Hospital, shown in this *c.* 1920 photo, was built in 1905 at the corner of Grand and Spruce Avenues, financed by Dr. Harry Plymire, one of the city's first physicians and a founding father. Dr. Plymire maintained an office on the main floor and handled emergency non–life threatening and industrial cases. Operations were performed at Mills Hospital in San Mateo. Dr. Plymire died in 1915, and the house was sold to Dr. Stephen Dolley, who, in 1917 had it moved to 519 Grand Avenue to make way for a new hospital. The building was then remodeled as a men's industrial club. The structure became a residential home sometime later, and in 1995 its owner, Margerete Schwarz, bequeathed it to the historical society. Today, the Plymire-Schwarz House is a museum center that includes a fire exhibit. (Courtesy of South San Francisco Public Library Local History Collection.)

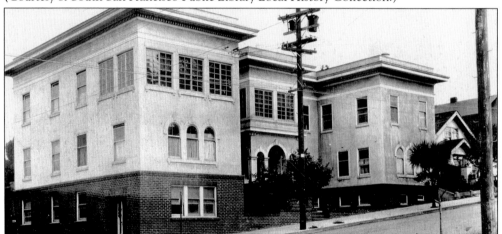

In 1918 the new South San Francisco General Hospital opened its doors at 500 Grand Avenue at an estimated cost of $50,000. The architect was A.I. Coffey. The building, shown in this *c.* 1950 photo, included 42 beds, 3 separate operating rooms (main surgical, emergency, and maternity rooms), 2 sun porches on the top floor, a general veranda, and a smaller solarium exclusively for women. Nurses were Annie Cunningham and Lillian Hafers. There was a board of seven directors headed by Dr. Dolley. Stock in the corporation was offered. A medical center was established in the 1940s, and Kaiser Permanente purchased the facility in 1953. (Courtesy of South San Francisco Public Library Local History Collection.)

Two
BIRTH OF
INDUSTRIAL CITY

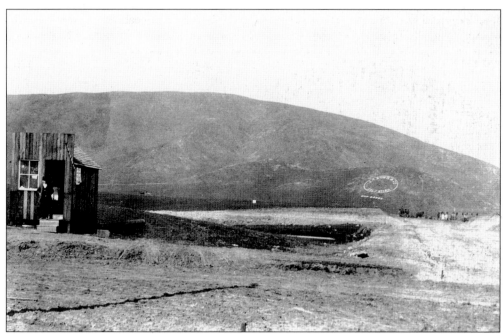

J.T. Dunn Real Estate was established in 1891 at Grand and Cypress Avenues in a one-room wooden shack. The first lot was sold that year for $250. As more and more industries moved to town, Dunn moved to a larger office at Grand and Linden Avenues, which was the center of the growing town. Dunn's Grand and Linden office, shown in this 1891 photo, also served as the post office for many years. (Courtesy of South San Francisco Public Library Local History Collection.)

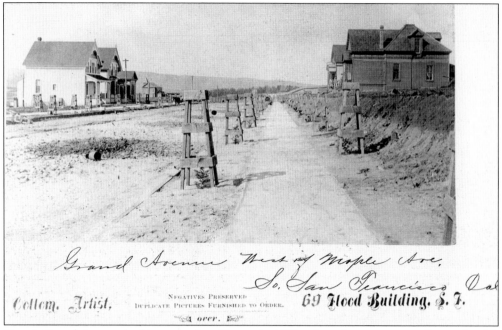

Here is Grand Avenue looking west from Spruce in 1893, when the streets were dirt roads with no sidewalks. The wooden posts in front of the homes protected the just-planted eucalyptus trees. Even then Grand Avenue was like a wind tunnel because of its direction, width, and length. As the trees grew, locals knew to wear a hat while walking along Grand to avoid being pelted by the acorn-like seeds from the eucalyptus. (Courtesy of South San Francisco Public Library Local History Collection.)

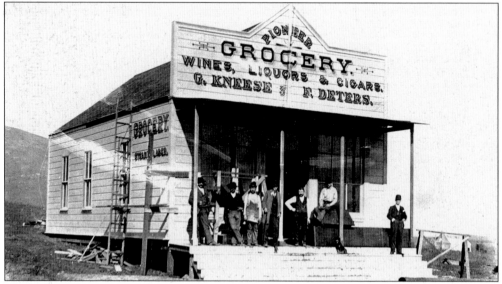

The Pioneer Grocery store, shown in this 1893 photo, was established in the early 1890s at Grand and Maple Avenues and was owned by George Kneese and F. Deters. The Pioneer advertised "wines, liquors and cigars" to attract the factory workers who comprised most of the population during the early years. Mr. Kneese stated that his stock "is extra choice and my prices cheaper than city prices." (Courtesy of South San Francisco Public Library Local History Collection.)

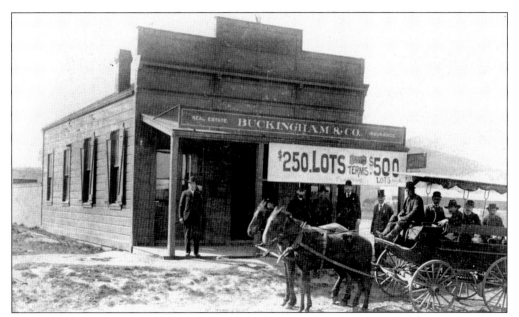

By 1897 San Francisco had forgotten the small district name of Baden and replaced it with the newer name South San Francisco. Real estate was booming and there wasn't a vacant home in town. Buckingham & Company Real Estate was established in the 1890s at Grand near San Bruno Road (Airport Boulevard) and developed the "Old Town" area. (Courtesy of South San Francisco Public Library Local History Collection.)

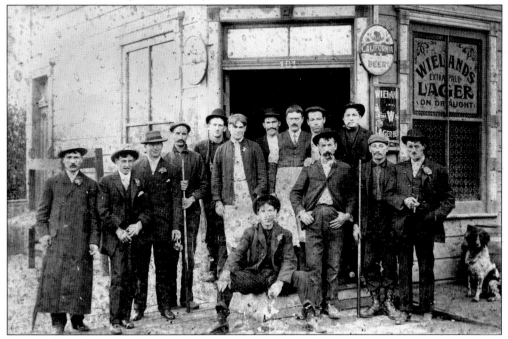

The Merriam Block housed an old saloon and hotel, shown in this 1910 photo, on the corner of Grand Avenue and San Bruno Road (Airport Boulevard). The hotel rooms were upstairs and downstairs was a bar and pool hall. (Courtesy of South San Francisco Public Library Local History Collection.)

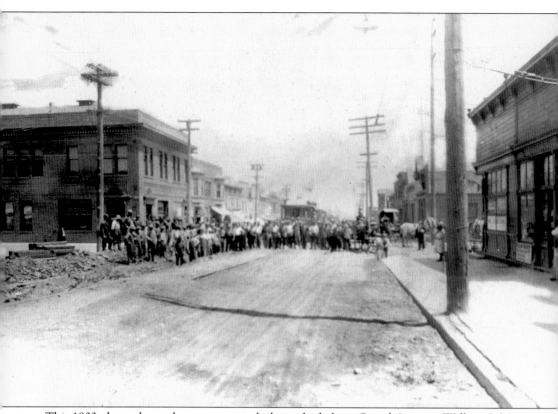

This 1903 photo shows the streetcar tracks being laid along Grand Avenue. William J. Martin, who headed the South San Francisco Land & Improvement Company, saw the need for a transportation system, so he formed the South San Francisco Railway & Power Company. The Grand Avenue streetcar started at Oak Avenue, where it connected with Grand and ended at Point San Bruno, past Western Meat and Fuller Paint companies. It was incorporated in 1903 for $100,000. (Courtesy of South San Francisco Public Library Local History Collection.)

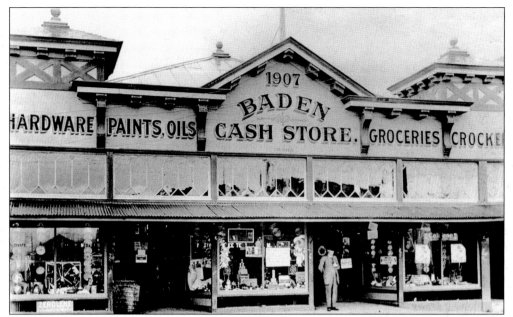

Baden Cash Store, shown in this c. 1908 photo, was established in 1907, located at 216 Grand Avenue, and operated by Hermes Gerdes. Baden Cash Store spanned what would be several storefronts on Grand Avenue today. The large two-story gingerbread-style store sold everything from groceries to nails and paints. (Courtesy of South San Francisco Public Library Local History Collection.)

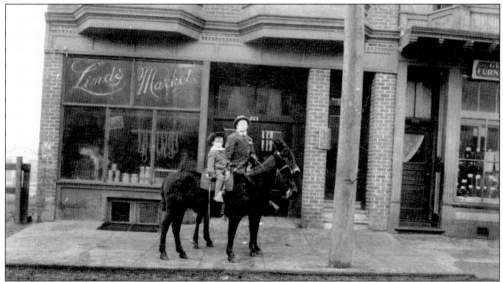

Lind's Market was established in 1905, located at 221 Grand Avenue, and owned by Swedish immigrant Peter Lind, seen in this 1905 photo with a child. Lind came to South San Francisco in 1895, soon becoming the town's leading retail meat dealer. He was a very successful businessman until Prohibition took his fortune. Federal agents closed Lind's Market in 1932 after they found "near beer" in his icebox. Lind set up shop in another store to continue serving his customers. He was an outspoken man who often battled town politicians. (Courtesy of South San Francisco Historical Society.)

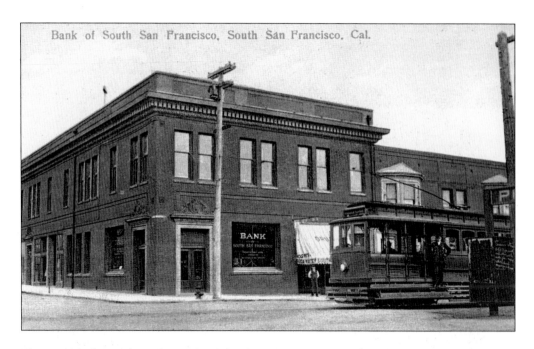

These 1905 photos show the Bank of South San Francisco, established in 1905 at Grand and Linden Avenues by P.N. Lilienthal of San Francisco. A number of investors, including Gustavus Swift and William J. Martin, put up $50,000 to open the bank. Below, the teller is Dave Martin and the cashier is Max Gluckman. (Courtesy of South San Francisco Historical Society.)

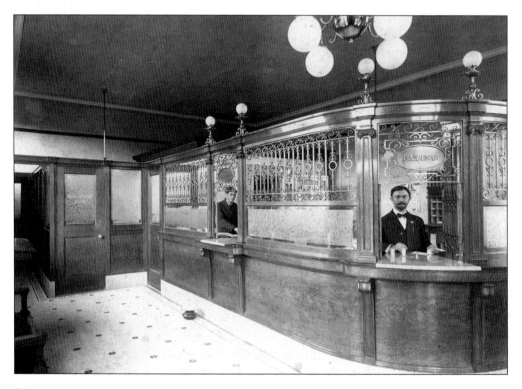

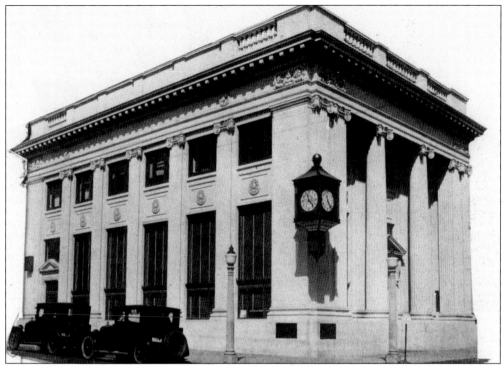

This 1918 photo shows the new, larger building of the Bank of South San Francisco when it moved across the street to 301 Linden. In 1955, Crocker National Bank purchased the Bank of South San Francisco. The building is still standing and is one of the largest buildings in the downtown area. (Courtesy of South San Francisco Historical Society.)

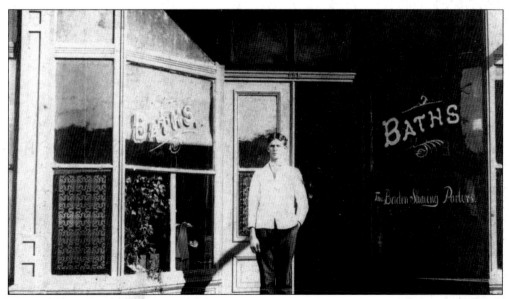

This c. 1907 photo shows a youthful Louie Ringue, standing in front of a commercial bath house, a place where men were able to go and wash, if facilities were not available at their living quarters. (Courtesy of South San Francisco Historical Society.)

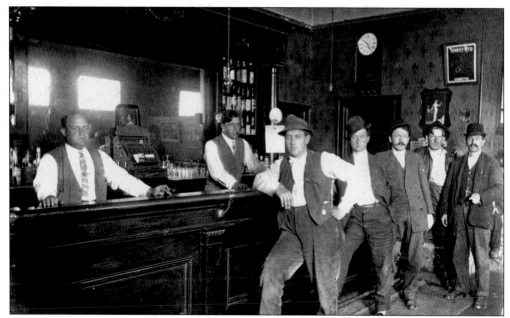

The Majestic Bar, shown in this *c.* 1900 photo, was located on Grand Avenue and was one of the earliest saloons in town catering to the hard-drinking factory workers who comprised most of the population through the 1890s and early 1900s. In 1900, saloons outnumbered churches by 16 to 1. (Courtesy of South San Francisco Public Library Local History Collection.)

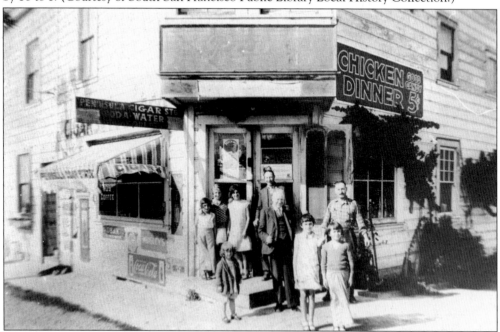

The Jacopi family ran a general store and restaurant, shown in this 1929 photo, on the 900 block of El Camino Real near West Orange Avenue. Next door to the Jacopis was the Peninsula Cigar Store. The signage advertised chicken dinners and good candy for 5¢. Above the store were apartments, which were common in many businesses of that era. (Courtesy of South San Francisco Historical Society.)

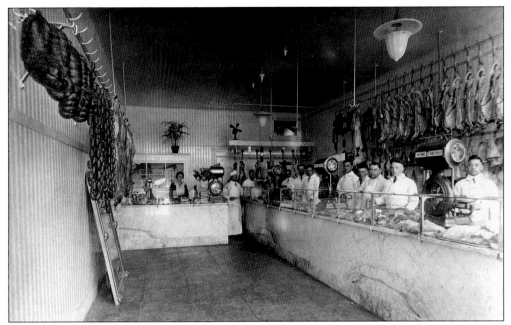

The Columbia Meat Market was established in 1920 at 217 Grand Avenue. The picture above is an interior view of the meat market in 1930. The Columbia Meat Market was in business until 1949. In 1944 the Vincenzini Brothers relocated the market to 220 Grand Avenue. (Courtesy of South San Francisco Historical Society.)

The Royal Theater was established in 1914 at 211 Linden Avenue and was operated by Al Eschelbach. The Royal was built during the silent film era and was not equipped to show motion pictures with sound. It closed in the late 1920s when talking pictures made their debut. The Royal and other silent movie houses were known as "nickelodeons," an offshoot of the penny arcades of the early 1900s. (Courtesy of South San Francisco Public Library Local History Collection.)

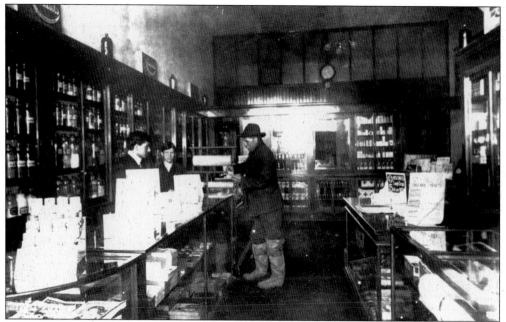

Peninsula Drug Company (a.k.a. Cavassa Pharmacy) was established in 1906 and located in various storefronts along Grand and Linden Avenues. Harry Cavassa was the pharmacist. Peninsula Drug was first located in the Plymire Hospital until 1925 when it closed, becoming a private residence. The drug store was then housed at 391 Grand until 1930 when it moved to 349 Grand where this photo was taken. (Courtesy of South San Francisco Public Library Local History Collection.)

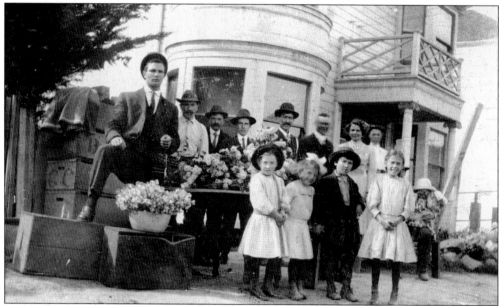

Pictured c. 1900 are the Rosaias (adults) and the Piccionis (children) standing in front of the Rosaia home on Chestnut at Miller Avenue. The Rosaias had one of the many family farms in town. They grew violets, which they sold by the bunch in their front yard. (Courtesy of South San Francisco Public Library Local History Collection.)

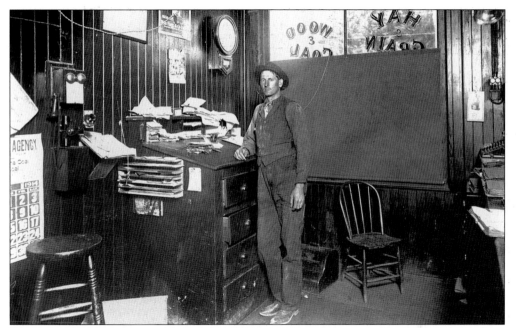

Kauffmann Brothers was established in 1906 at 316 Grand Avenue. Kauffmann's was a hay, coal, and drayage company. Pictured is Ed Kauffmann in the office in 1914. He also served as city treasurer for 50 years. Kauffmann Brothers remained in business until 1954. (Courtesy of South San Francisco Public Library Local History Collection.)

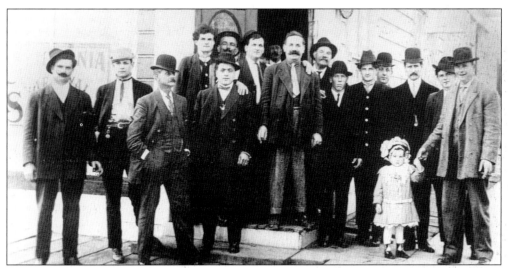

A name that continues to be listed on a storefront in the South San Francisco is Giorgi. First was Bertuccelli & Giorgi's grocery store in 1908 at 116 Grand Avenue; in 1915, there was A. Giorgi & Company Saloon; then there was Agusto Giorgi's grocery store on the 200 block of Baden Avenue. His sons switched the line of business to furniture in 1933. This photo depicts a group of men standing in front of the grocery store c. 1912, with Agusto Giorgi holding the hand of his daughter Violet, who succumbed to tuberculosis at the age of 22. The family home was located on Third Lane. Giorgi's Furniture Store is still the largest family-owned furniture store in the Bay Area. (Courtesy of Rob Giorgi.)

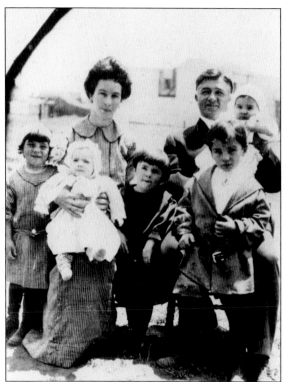

The Jennings was one of the early families to settle in South San Francisco. Both Mr. and Mrs. Jennings were licensed pharmacists and operated Jennings Pharmacy, established in 1917 on the 200 block of Grand Avenue. The family poses in this c. 1924 photo. From left to right, they are (front row) Frances, May, and Eugene; (second row) Mary (Rossi) Jennings holding Agnes, and James Jennings holding James Jr. Agnes became a doctor and had her practice above the pharmacy. Jennings Pharmacy, shown below in a c. 1924 photo, remained in business until 1974. (Top photo courtesy of South San Francisco Historical Society; bottom photo courtesy of South San Francisco Public Library Local History Collection.)

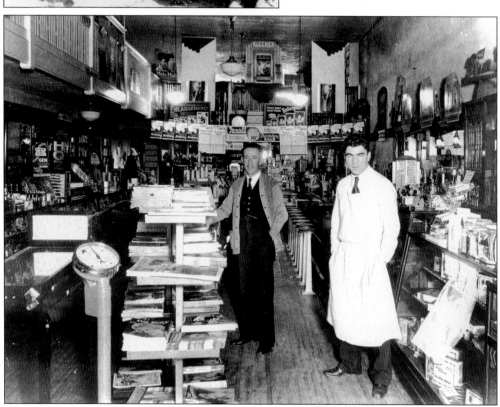

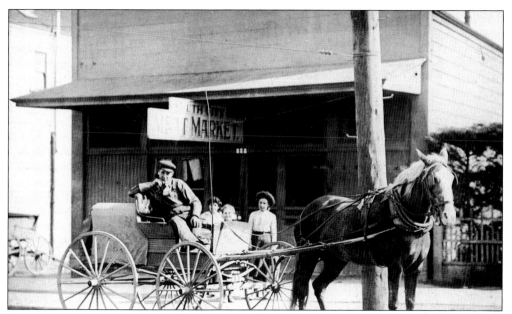

This *c*. 1912 shows wagoner Bill Burgman parked in front of the South City Meat Market at 225 Grand Avenue. Several meat markets ran their business here. In the 1890s it was Dervin's Meat Market; in 1899 it was Ed Pike's Market and Coombes Meats; in 1912 it was Davis's South City Meat Market; in the 1920s it was Bonalanza's soft drink business; and in 1929 it was Rock's Auto Sales and Service. (Courtesy of South San Francisco Historical Society.)

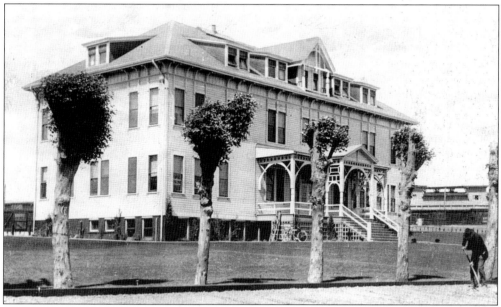

Western Meat Company's three-story South San Francisco Exchange Building, shown in this 1928 photo, was completed in 1893 and was located on the 200 block of East Grand Avenue. The first floor housed offices and the company's bank. The basement housed a barbershop and bathrooms. A dining room, reading room, and bar occupied the second floor. The third story was reserved for bedrooms and apartments. The Exchange remained open until 1932. (Courtesy of South San Francisco Public Library Local History Collection.)

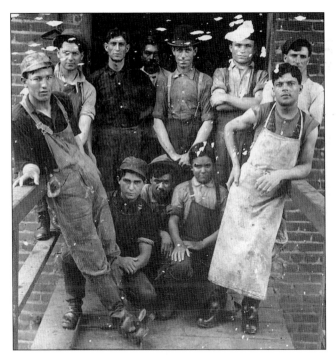

This 1904 photo shows Western Meat Company butchers taking time out. Western Meat Company was the biggest employer in South San Francisco for many years. At the turn of the century the town was providing steady employment for more than 500 men, most of them at Western Meats. The slaughterhouse and meat packing plant cost more than $2.5 million to construct. Extensive mechanization increased the output per worker and drove down the wages, as the majority of employees became common laborers rather than skilled butchers. (Courtesy of South San Francisco Public Library Local History Collection.)

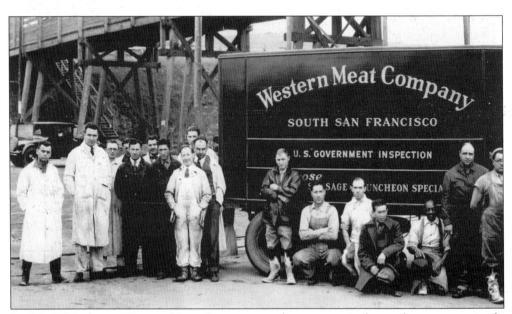

In this 1930 photo, Western Meat Company employees pose in front of a company truck. (Courtesy of the South San Francisco Historical Society.)

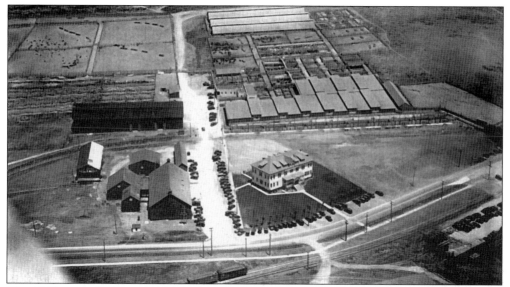

This 1929 view of Western Meat Company, the Exchange, and the stockyards looks east. By the turn of the century, Western Meat slaughtered approximately 1,000 head of cattle per week. Along with cattle and calves, lambs, pigs, and sheep were brought to South San Francisco for slaughter. (Courtesy of South San Francisco Historical Society.)

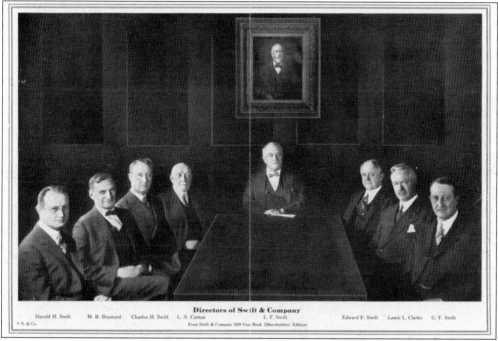

The Swift family, one of the first major stockholders in Western Meat Company, started buying up the company's stock in 1913 and attained complete control in 1932 for a transfer fee of $1. They operated at 200 East Grand Avenue from 1932 to 1968. The board of directors in this 1929 portrait includes, from left to right, Harold H. Swift, M.B. Brainard, Charles H. Swift, L.A. Carton, L.F. Swift, Edward F. Swift, Lewis L. Clarke, and G.F. Swift. (Courtesy of South San Francisco Public Library Local History Collection.)

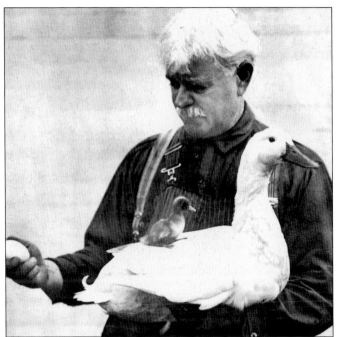

Reichardt Duck Farm was originally established in San Francisco in 1901 by Amalia and Otto Reichardt, on Onondaga Street across from Balboa High School. They outgrew their small farm in 1917 and moved to 1330 Mission Road, the present location of El Camino High School. The farm sold an average of one million ducks a year along with 360,000 duck eggs. Reichardt is shown here pondering a duck egg, while holding one of his ducks and duckling. (Courtesy of South San Francisco Historical Society.)

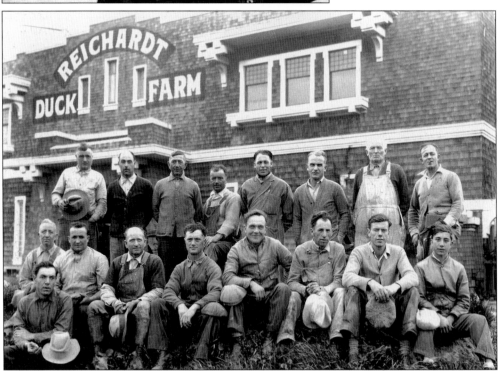

Here are Reichardt Duck Farm employees at the South San Francisco location, c. 1930. Reichardt Duck Farm sold ducks primarily to Chinese markets in San Francisco, Oakland, and Sacramento. The duck farm was forced to move to Petaluma in the early 1950s when South San Francisco took the land by imminent domain to build El Camino High School. (Courtesy of South San Francisco Public Library Local History Collection.)

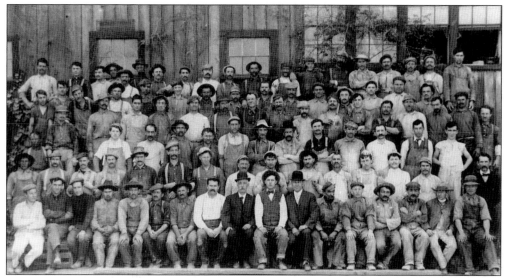

Steiger Terra Cotta employees pose in this 1909 photo. The company, established in 1895 on East Grand Avenue, was enticed to move to South San Francisco by William J. Martin. Steiger specialized in pottery, bricks, mantels, sewer pipe, and terra cotta. The company went bankrupt six months after opening; however, it reopened within the year. The business continued successfully until 1917 when it was destroyed by fire. The president of the company blamed the fire on arson, alleging labor problems, but the charges were never substantiated. (Courtesy of South San Francisco Historical Society.)

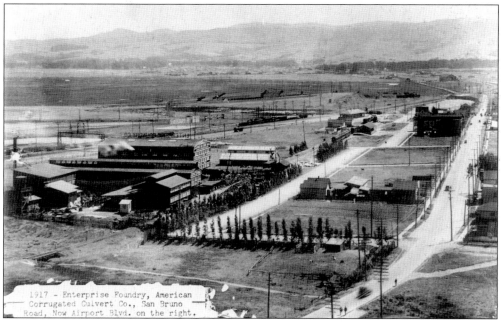

1917 - Enterprise Foundry, American Corrugated Culvert Co., San Bruno Road, Now Airport Blvd. on the right.

Enterprise Foundry was established in 1911 on Division Avenue (now Dubuque). The foundry, shown in this 1917 photo, occupied four buildings totaling 50,000 square feet. It was the largest metal casting company on the West Coast. Within the foundry were a brake and shoe foundry and a full machine shop. Enterprise Foundry made all the fire hydrants in San Francisco and remained in business until 1960. (Courtesy of South San Francisco Historical Society.)

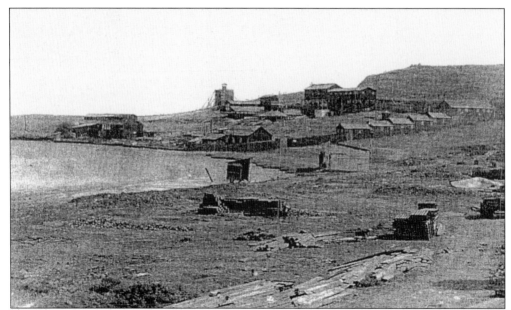

Wildberg Bros. Company, shown in this c. 1900 photo, was established in 1907 in San Francisco and was owned by the Wildberg family. Wildberg's specialized in reclaiming waste and secondary material containing gold, silver, or platinum, melting it down, and reselling the metals. In 1920, Wildberg's purchased a smelting plant at 349 Butler Avenue (now Oyster Point Boulevard), establishing the Wildberg Bros. Refining Works, which operated until 1962. (Courtesy of South San Francisco Public Library Local History Collection.)

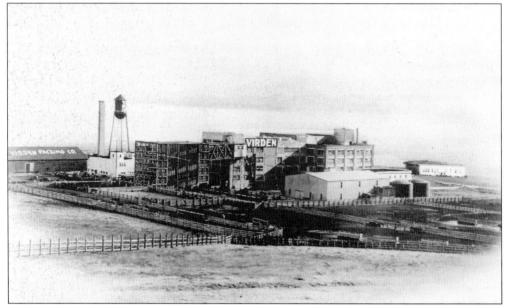

Virden Packing Company was established in 1913, the date of this photo. In 1916 Armour built a meat packing plant nearby. Within two years Virden and Armour merged, forming the Virden Armour Packing Company. The company prospered following World War I, but Virden fell into financial ruin after the stock dropped from $100 to just $5. In 1935 Armour took over Virden and remained in business into the 1980s. (Courtesy of South San Francisco Historical Society.)

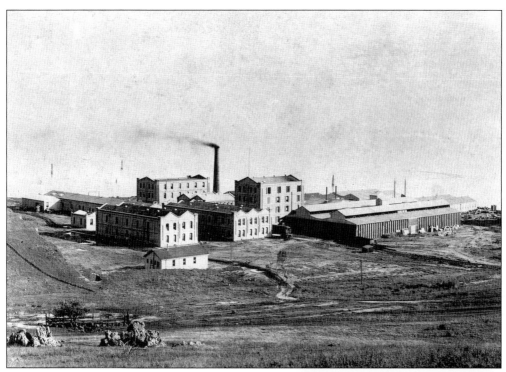

W.P. Fuller arrived in San Francisco in 1849 to sell supplies to gold miners and soon went into the paint business. His company had a devastating fire in 1892, and William J. Martin courted him into moving to South San Francisco. A site was chosen at Point San Bruno to construct the largest paint and varnish works on the West Coast, shown in this *c.* 1900 photo. Fuller sold the company after World War II to Hunt Foods after third-generation family members were no longer interested in running the business. Hunt sold to O'Brien Paint Company in 1967. Fuller-O'Brien remained in business through the 1990s. (Courtesy of South San Francisco Public Library Local History Collection.)

The drainpipe (scoper) in this 1992 photo was attached to one of the original brick buildings at the W.P. Fuller & Company. It has an 1898 production mark. The pipe was bequeathed to the South San Francisco Historical Society when the building was demolished in 1993 and is currently in storage at the Plymire-Schwarz House. Many of the bricks from the buildings, when demolished, were given to the historical society and used for various walkways around the Plymire-Schwarz House and Carnegie Library. (Courtesy of South San Francisco Public Library Local History Collection.)

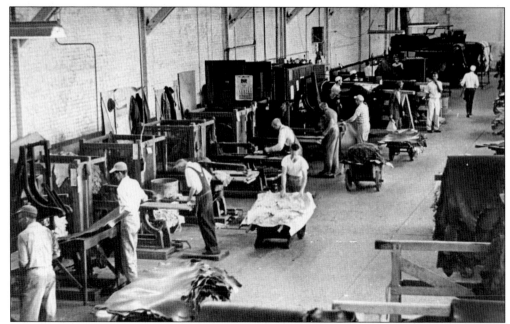

Shown in this *c.* 1950 photo, Poetsch & Peterson Tannery (1883–1985), owned by Herman Poetsch and Gustave Peterson, was a hide-processing plant. Originally established in San Francisco, it moved to 325 South Maple Avenue in 1943. The company tanned garment leather for police motorcycle jackets, shoe upper leather, and mechanical leather for gaskets and oil seats. It also did custom tanning for hunters. (Courtesy of South San Francisco Public Library Local History Collection.)

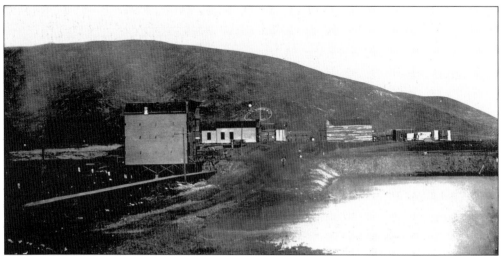

This is San Bruno Road as it looked in 1893. In 1924, as groundbreaking for the new "super highway" from San Francisco to San Jose began, San Bruno Road was renamed Bayshore Boulevard (later changed to Airport Boulevard). In 1929 Bayshore Boulevard extended to San Mateo. (Courtesy of South San Francisco Public Library Local History Collection.)

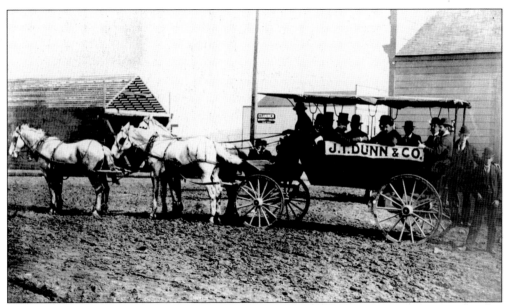

J.T. Dunn, the town's real estate company that opened in 1891, provided the horse-drawn bus for prospective buyers. Dunn would take them on a tour of the town, such as it was in 1892, and feed them lunch, hoping he would make a sale. This 1892 photo was taken at the intersection of Grand and Linden Avenues. (Courtesy of South San Francisco Public Library Local History Collection.)

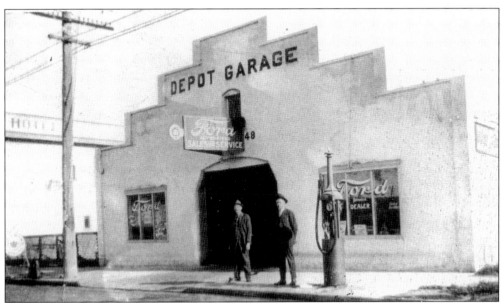

This 1920 photo depicts Depot Garage, the city's first Ford dealership, repair shop, and service station (note the gas pump at curb). The garage was located at 412 San Bruno Road (Airport Boulevard). Proprietor Fred Lautze is on the right. He later moved his business across the street to the expanded Lautze Ford. Painted on the façade of the building is the phone number, 48. (Courtesy of South San Francisco Public Library Local History Collection.)

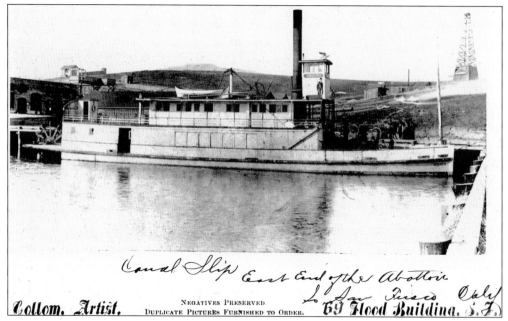

Here is a paddleboat docked at the canal slip at the end of East Grand Avenue in 1893. The canal slip area is where the shipyards were located during World War I and World War II. Vessels were charged a dredging fee to pass through the channel and dock in South San Francisco. (Courtesy of South San Francisco Public Library Local History Collection.)

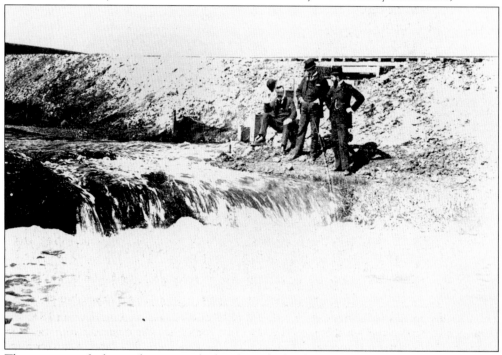

Three men watch the creek run into the bay from the bank near Railroad Avenue in the 1890s. At that time Railroad Avenue was at the edge of the bay. (Courtesy of South San Francisco Public Library Local History Collection.)

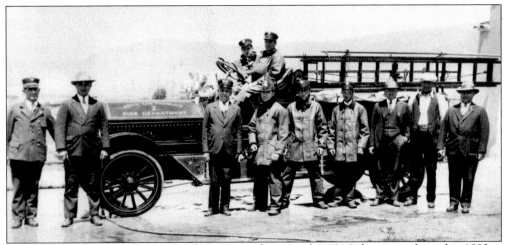

South San Francisco's volunteer fire department, shown in this 1916 photo, was formed in 1892 as Hose Company No. 1 and consisted of a handful of volunteers and one hose cart. In 1895 the Citizens Mutual Protective Association formed and bought a fire bell to call out the volunteers.Hose Company No. 1 disbanded in 1900 when the cotton hose wore out and was resurrected in 1903 with 25 volunteers and hose and ladder carts. (Courtesy of South San Francisco Historical Society.)

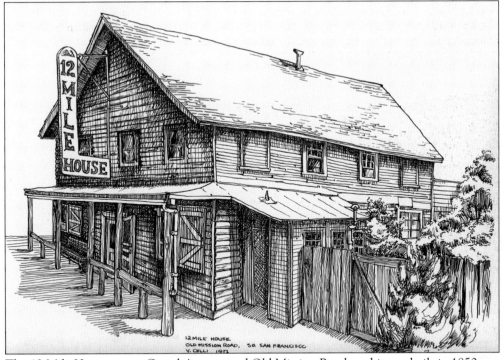

The 12 Mile House was at Grand Avenue and Old Mission Road, and it was built in 1850 as a chain of stagecoach stops for the San Francisco–San Jose route. The original owner was John Cumming. In 1924 the structure was bought by the Bergamaschi family as a home and boarding house. After Prohibition, a saloon and dinning room were added. The building was demolished in the 1990s for a residential development. This sketch was drawn by South San Francisco schoolteacher Virginia Cella in 1971. (Courtesy of South San Francisco Historical Society.)

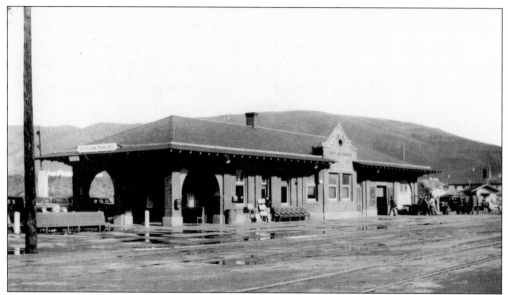

The Southern Pacific's Railroad Station was built in 1909 at the foot of Grand Avenue. The building, shown in this c. 1940 photo, was demolished in the late 1950s. Southern Pacific's line between San Francisco and San Jose was completed in 1907. Southern Pacific's mainline ran through South San Francisco because of the huge industrial base of goods in need of shipping. Many of the industrial companies built tracks to their warehouses connecting to Southern Pacific's mainline for ease of shipping. (Courtesy of South San Francisco Historical Society.)

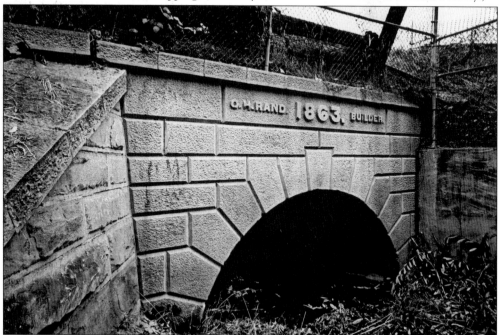

This c. 1995 photo shows where the San Francisco–San Jose Rail Line ran over this culvert on Spruce Avenue, built to take care of winter rains and alleviate the flooding of Colma Creek, which halted the only means of transportation. The line was taken over by Southern Pacific in 1868. (Courtesy of South San Francisco Historical Society.)

Three

WAR YEARS

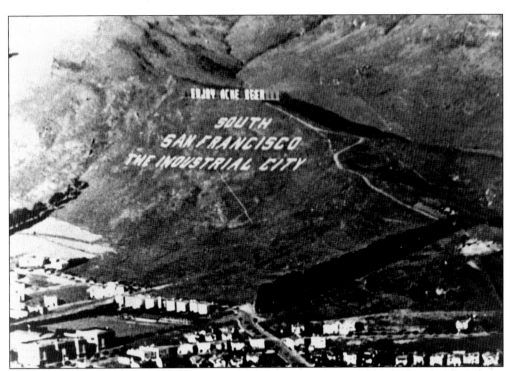

Sign Hill originated in 1923 when the chamber of commerce commissioned workers to etch the town's motto with powdered lime on the side of the hillside. In April 1929 the Cement Gun Construction Company of South San Francisco made the letters permanent at the cost of $4,845 after voters approved (by a margin of 3 to 1) a 7¢ city tax for this purpose. The sign became a national historic landmark through the efforts of Edna Harks, town historian and activist, in 1996. The less historic electrical sign that flashed multiple messages was destroyed by heavy winds in the 1940s. (Courtesy of South San Francisco Historical Society.)

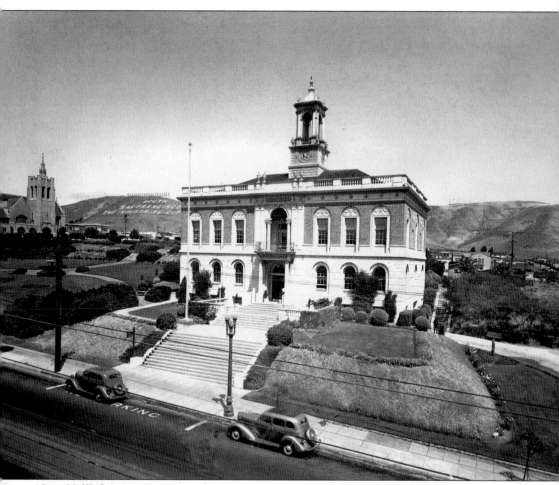

City Hall, shown *c.* 1930, was built in 1920 and is a replica of Philadelphia's Independence Hall. The building housed city offices, the police and fire departments, and courtrooms on the second floor. The auto parked in the "No Parking" zone belonged to the police chief, Louis Belloni. The front steps and balcony were used as a reviewing stand for parades. The Marianne Greenleaf Martin Fountain was erected in the civic center in 1929 through the generosity of the South San Francisco Women's Club. The flagpole was donated by the American Legion and dedicated on July 4, 1923. All Souls Church is the building on the left. (Courtesy of South San Francisco Historical Society.)

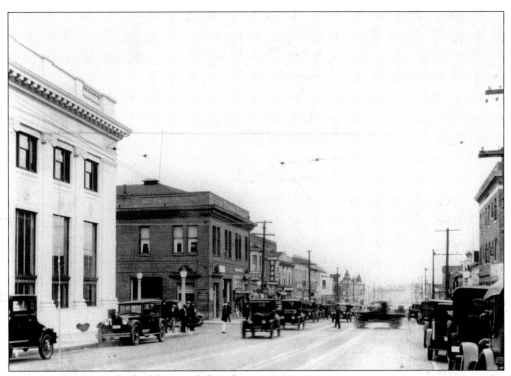

In this 1926 photo, the building on left is the Bank of South San Francisco at 301 Linden Avenue. The building in the center is the Bank of Italy (later Bank of America), and upstairs was the American Legion Hall (formerly Metropolitan Hall and named by the Land Company). During World War II, USO dances were held in the building's larger hall, known as the Hospitality House. It existed on voluntary contributions, and civic groups served refreshments once or twice a month to all servicemen. The operation ran until 1945. Churches also used the space when starting up in town. The Metropolitan Hotel is the building on the far right. (Courtesy of South San Francisco Public Library Local History Collection.)

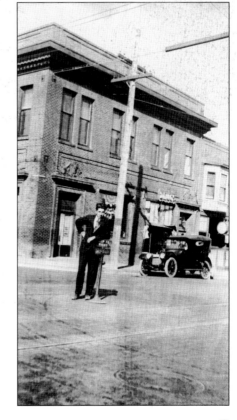

In this 1917 photo, Charles Sands is standing at the corner of Grand and Linden Avenues in front of Bank of South San Francisco (later Bank of America), leaning on a traffic divider sign. During his high school years, Sands worked in the drug store after school. He later became an employee for Metal & Thermit as an assistant foreman. (Courtesy of South San Francisco Historical Society.)

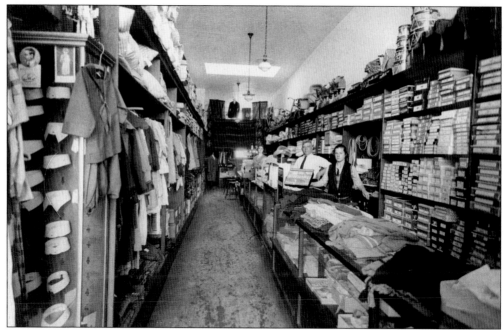

The town's dry goods store was "The Hub," located in the Vincenzini Building at 383 Grand Avenue. The proprietor, Charles Guidi, and daughter Theresa Guidi Clark are tending to business in 1945. (Courtesy of the South San Francisco Historical Society.)

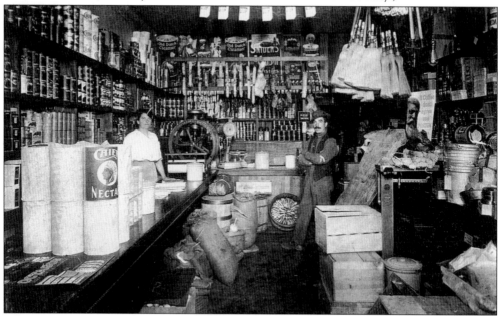

Anyone who entered Charles Bollazzi's General Merchandise and Grocery Store at 313 Grand Avenue always remembered the tantalizing aroma of salami, mortadella, and cheese that permeated the premises. In this 1915 photo, Mrs. "Mariucha" Bollazzi greeted each customer with a hearty welcome and beckoned her husband ("Charling") when she needed items on a top shelf. If an item couldn't be found on a shelf, "Charling" would retrieve it from the cavernous basement. (Courtesy of South San Francisco Historical Society.)

On Friday, October 2, 1931, the doors were opened for South San Francisco's newest theater, the State Theater at the corner of Linden and Baden Avenues, only a few yards from the Royal Theater. Proprietor of both theaters was Al Eschelbach. Movies were held three times a week with Wednesday nights known as "Dish Night." Next door to the theater was a hardware store and near Third Lane was Nieri Funeral Home. All Souls' Church held services in the theater in the mid-1960s when the church was destroyed by fire. Giorgi Bros. Furniture later purchased the building as a social hall and upholstery and drapery business. (Courtesy of South San Francisco Public Library Local History Collection.)

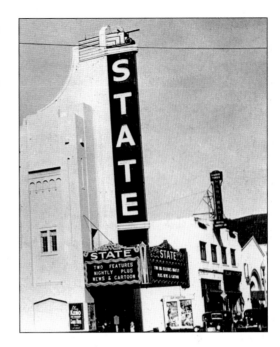

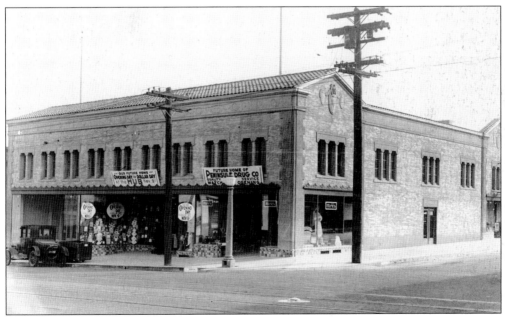

The Vincenzini Building, at Grand and Maple Avenues, was built in 1927. Businesses located here were the Peninsula Drug Company (later Anchor Drugs) operated by Harry Cavassa; the Hub, a dry goods store, operated by the Guidi family; and Belluomani Shoe Repair, its entrance on Maple Avenue at the far end of the building. During World War II, there was a booth in front of the building where liberty bonds were sold. (Courtesy of South San Francisco Public Library Local History Collection.)

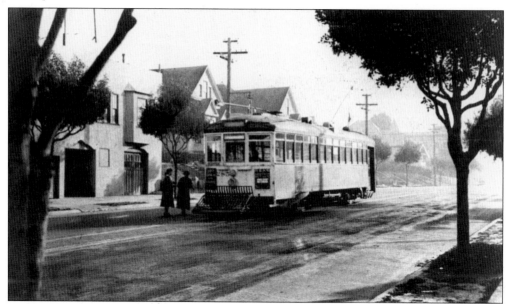

At the west end of Grand Avenue was Leipsic Junction where the Market Street Railway 40 Line from San Francisco to San Mateo met the street car that transported workers to meatpacking and other manufacturing plants on East Grand Avenue, ending at Fuller Paints. The 1938 scene is car #285 in December, two weeks prior to the line's abandonment and by this time only morning and evening service was provided. The line operated from 1918 to 1938 by the South San Francisco Railroad & Power Company, formed by William J. Martin. (Courtesy of South San Francisco Historical Society.)

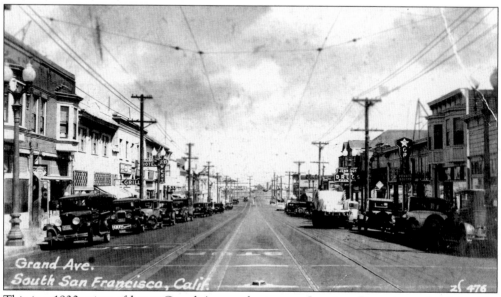

This is a 1930s view of lower Grand Avenue businesses. Jennings Drugs is on the right side; across the street are Giffra's Grocery store, the West Hotel and grill, barbershop, and cleaners. Running down the middle of the street are the tracks for the streetcars. (Courtesy of South San Francisco Historical Society.)

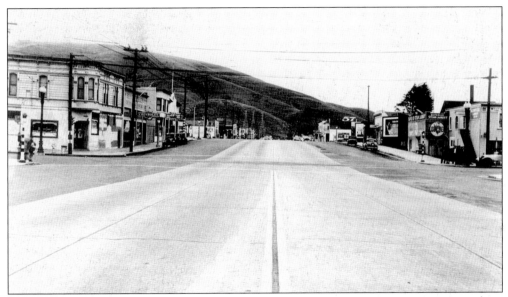

This is Bayshore Boulevard (later called Airport Boulevard) during the late 1930s at a quiet moment. On the right are buildings that were later torn down when Highway 101/Bayshore Freeway was built. On the left is the Merriam Block, a rooming house on the second floor, and a saloon on the corner with a ladies entrance on the boulevard side. A variety of stores started on the main floor, including Eikerenkotter's General Store. Dr. A.J. Holcomb and his family lived here while his home was being built at the corner of Grand and Eucalyptus Avenues. (Courtesy of South San Francisco Public Library.)

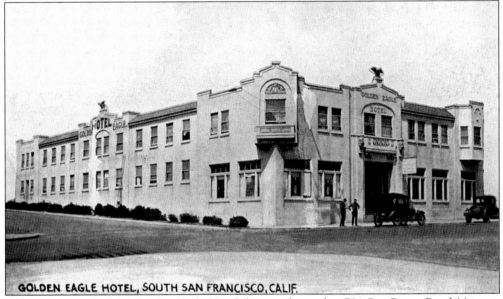

GOLDEN EAGLE HOTEL, SOUTH SAN FRANCISCO, CALIF.

This is a postcard of the Golden Eagle Hotel that was located at 701 San Bruno Road (Airport Boulevard) from 1955 to 1976. It was also located at 702 Pine Avenue from 1918 to 1927. It was both a hotel and restaurant and one of the largest in town. It advertised 100 sunny rooms and reasonable rates. (Courtesy of South San Francisco Historical Society.)

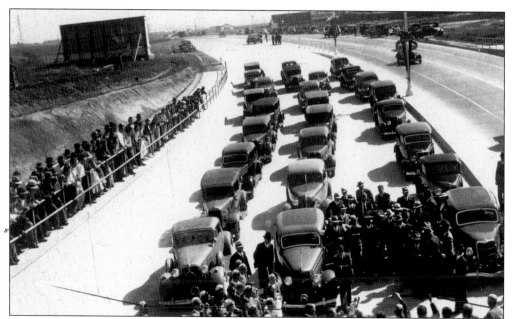

September 16, 1927 marked the opening day of Bayshore Road, which lead into South San Francisco through the completed railroad underpass. Charles "Lindy" Lindbergh was part of the motorcade that traveled through the underpass after landing at Mills Field. People young and old lined up along the road to catch a glimpse of the famous aviator. (The second boar was completed in 1935.) (Courtesy of South San Francisco Historical Society.)

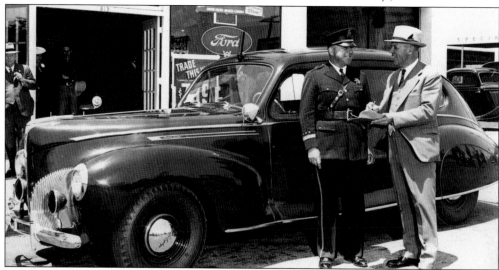

Louis Belloni accepts a police car in 1940 from Fred J. Lautze, of Lautze Ford at 315 San Bruno Road (Airport Boulevard). In the background, from left to right, are former mayor George Holston, Theresa Lautze, and an unidentified man. The car was a gift from the San Francisco *Call Newspaper* for the price of 300 new subscribers, an offer the newspaper advertised and Chief Belloni capitalized on. Chief Belloni joined the police department in 1922 and in 1924 was made chief, a position he held for 38.5 years. He was also a volunteer fireman from 1928 to 1930 and acting fire chief until Al Welte was hired. (Courtesy of South San Francisco Public Library Local History Collection.)

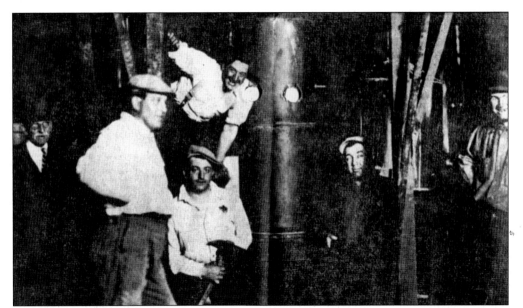

Here Chief Belloni is with the South San Francisco day squad busting up a distillery during Prohibition. It was legal to make a limited amount of wine for personal consumption, and grapes were purchased from local grocery stores that arrived on cattle cars at the Southern Pacific depot. Greek families purchased grapes to make retsina. Gambling and illegal liquor kept the police chief busy. The most popular account told is when the new firm J.R. Roberts Soda Factory was raided in 1931, a huge still was concealed in a large water tower. (Courtesy of South San Francisco Historical Society.)

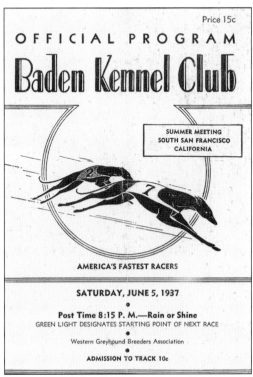

Baden Kennel Club Track was located on the marshy west end of South San Francisco, within the view of Tanforan Race Track, during the 1930s. Admission was 10¢. Sleek greyhounds chased a mechanical rabbit around a track and maybe a fan would win a couple of dollars by placing a wager on his favorite canine. Wagering, of course, was illegal and county officials raided the track in 1934, arresting 15 people, including a former South San Francisco councilman. The Baden dog track eventually became a non-issue and went out of business during the Great Depression. (Courtesy of South San Francisco Historical Society.)

This is the new East Grand Avenue fire department substation for volunteer firemen shown c. 1940. A. Zangrando, D. Pallo and B. Pianca, local contractors, built the building. Standing around the 1916 and 1927 Seagrave engines and 1940 La France engine are Chief Welte and Assistant Chiefs Brauns and Marchi (left). The first volunteer fire department was organized in 1892 with Henry Jones as chief. A small bell was hung at the corner of Linden and Grand Avenues and when it rang everyone ran to pull the hose cart. (Courtesy of South San Francisco Historical Society.)

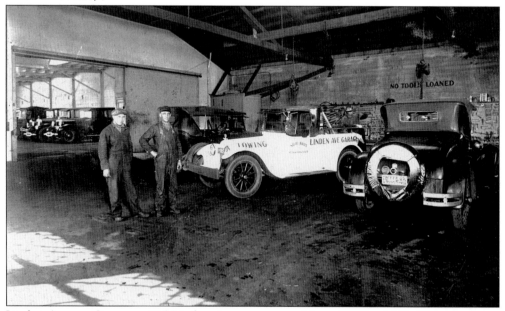

Linden Avenue Garage at 105 Linden Avenue operated from 1925 to 1943. The proprietor, Frank Bertucelli, was a councilman from 1963 to 1967 and mayor in 1965. Arata Bros. bought the garage sometime later, and an auto repair garage exists at the location today. (Courtesy of South San Francisco Public Library Local History Collection.)

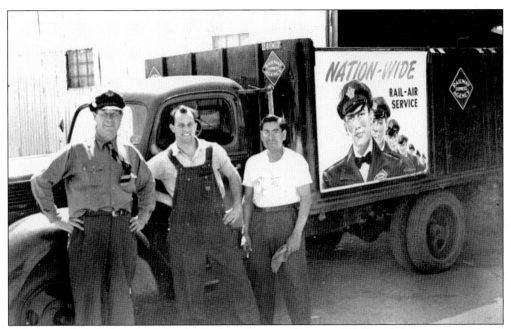

A business ahead of its time was the Railway Express Agency, 451 Grand Avenue, owned and operated by Ralph Hilbun. This picture depicts Mr. Hilbun (at left) with others in front of the company express truck. The service operated during the 1940s. (Courtesy of South San Francisco Public Library Local History Collection.)

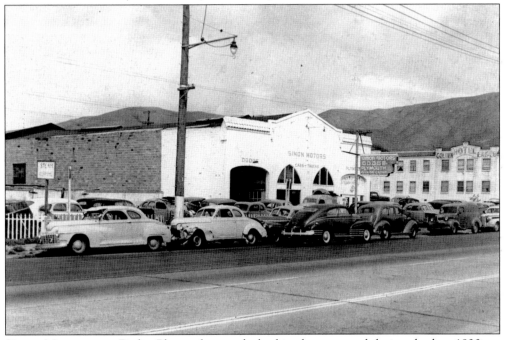

Simon Motors was a Dodge-Plymouth auto dealership that operated during the late 1930s to 1940s. It was located on Bayshore Boulevard (Airport Boulevard) at Pine Avenue, next to the Golden Eagle Hotel. (Courtesy of South San Francisco Public Library Local History Collection.)

The Nicolopulos family ran the Superior Laundry at Grand Avenue and San Bruno Road (Airport Boulevard) and, across the street, the Oxford Hotel boarding house on Lux Avenue. This 1920s picture depicts the Nicolopulos children, from left to right, Kaye, Alice, Tom, and Gus standing at the entrance to the living quarters at the hotel with Mr. Andrew Gidas. Gus and Tom could be found at the hotel tending bar and peeling hundred of potatoes to feed the boarders. Mrs. Nicolopulos managed the Greyhound Bus Depot during the 1940s. Today the area where the steam laundry once stood is a landscaped entrance to Highway 101 dedicated to Gus Nicolopulos in memory of his hard working family. (Courtesy of South San Francisco Historical Society.)

Standing in front of Spuri Studios in 1927, from left to right, are John Tacchi, bar owner; Sil Nieri, local mortician; and Jim Spuri, proprietor. The photography studio was in operation from 1927 to 1985. Mr. Spuri took portraits, school pictures, and group photos. It is said that Mr. Spuri would whistle like a canary so the subject being photographed would relax. All of his "colored" pictures were hand painted at the studio by Dawn Andrews, dressed in a "beret" and a painter's smock. (Courtesy of South San Francisco Public Library Local History Collection.)

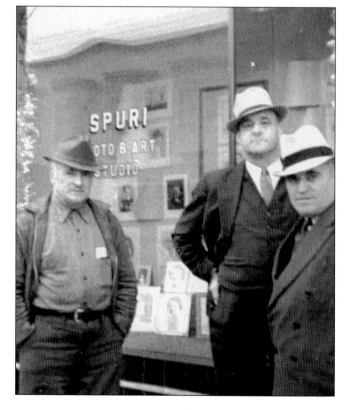

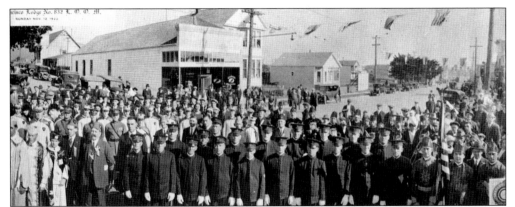

This is a 1922 picture of South San Francisco Loyal Order of the Moose Lodge #832, during the LOOM degree-initiation parade at the corner of Grand and Maple Avenues. (Courtesy of South San Francisco Historical Society.)

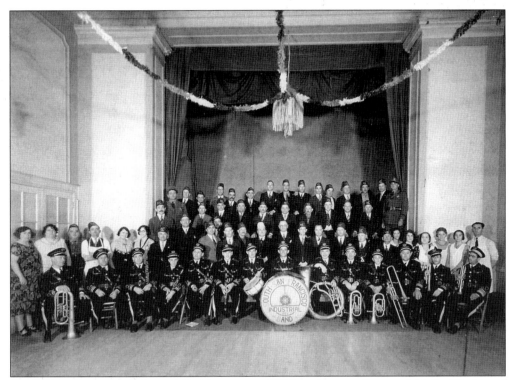

South San Francisco Industrial Band poses in 1927 at the new Fraternal Hall, 411 Grand Avenue. Members include Augie Terragno, Battista Rodondi, Pasquale Santini, Victor Boido, Joseph Quinlan, Leo Raugi, Leo Eserini, Umberto Baldini, and Peter Raugi. (Courtesy of South San Francisco Historical Society.)

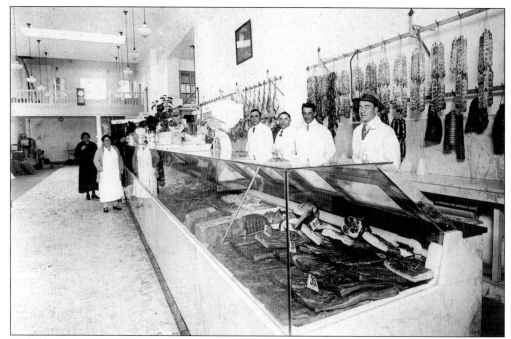

This is the interior of the California Palace Market, located at 381 Grand Avenue. Pictured c. 1930 behind the counter, from left to right, are an unidentified person, Frank Vincenzini, Tom Galli Sr. and Frank Batella. (Courtesy of South San Francisco Historical Society.)

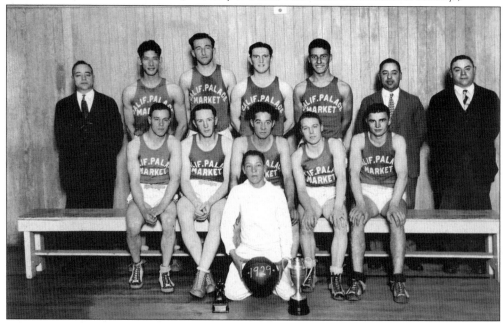

Vincenzini's California Palace Market sponsored and participated in the 1929 basketball team that included players, from left to right, (kneeling) Maundo Sari; (front row) Virgil Ringue, unidentified, George Molinari, Fred Weltie, and unidentified; (back row) Angelo Vincenzini, Gene Jordan, unidentified, Levio Raffaelli, unidentified, Lawrence Vincenzini, and Frank Vincenzini. (Courtesy of South San Francisco Historical Society.)

The 1939 Italian Catholic Federation Drill Team #7 members, from left to right, are Jennie (Bottini) Pariani, Josephine (Franzetti) Uccelli, Alice (Garbarino) Ekstrom, Gemma (Fiorentini) Negro, Annie (Barberis) Paganucci, and Ida Penna. (Courtesy of South San Francisco Historical Society.)

The theatrical production *Up in the Air* was performed in 1929 by South San Francisco High School students, from left to right, are (sitting) Juliet Enderlin, Kathryn Hogan, Barbara Hardy, Eleonore Fourie, Louise Sassmann, and Edith May Spindler; (standing) Marian Cavassa, Walter Fouts, George Pariani, Rose Genovesi, Leo Cortesi, Agnes Rosaia, Curtis Swan, Mary McGraw, Gerald Quinlan, Zoe Leggero, Euvelle Enderlin, Ruth Bernardo, Ernie Flink, Marie Balbi, Fred Castro, Gina Puccetti, George Wishing, and Betty Hardy. (Courtesy of South San Francisco Historical Society.)

South San Francisco High School, Spruce Campus, shown in 1917, was the city's first high school. The annex, housing industrial arts and the boys' gymnasium, was added in 1926 and enlarged in 1934 to hold classrooms and a girls' gymnasium. When the present South San Francisco High school was completed in 1951, this structure was used for intermediate grades. A major part of the building was demolished in 1959 and the remaining structure was modernized in 1958 and 1966. The annex, Spruce Gymnasium, was remodeled and rededicated in 1986. (Courtesy of South San Francisco Historical Society.)

Marguerite Cavassa Westh and Rue Randall Clifford, affectionately known as Cliffie, were photographed c. 1950 during a high school faculty meeting. Westh, a native of South San Francisco, taught Spanish for more than 30 years. She was a charter member of the historical society and a 50-year member of the Eastern Star. She was the daughter of Harry Cavassa, who established the Peninsula Drug Store at Grand and Linden in 1905. Her mother, Lillian Cavassa, was one of the first nurses stationed at South San Francisco Hospital. Cliffie, was an acclaimed English instructor at South City High since its 1913 opening and a rabid blue and gold graduate of Cal Berkeley. She loved to dance, waltz, fox-trot, and play the piano. She was very active in keeping the Hospitality House going for service men during World War II. (Courtesy of South San Francisco Historical Society.)

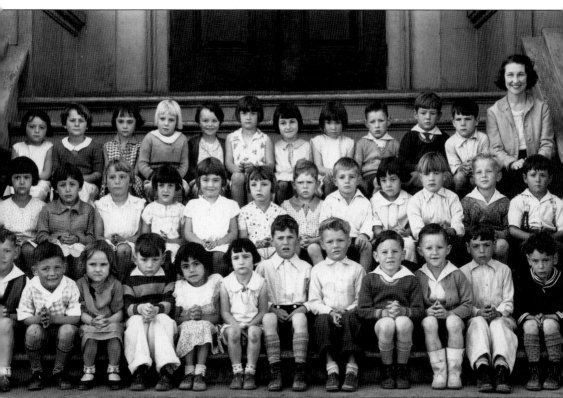

The 1932 Grand Avenue Grammar School class members, from left to right, are (front row) Bernard Hjerpe, Jack Wallace, Dorothy Helen Holes, Carlo Bonino, Juanita Russo, Mary Rovere, Renaldo Angelini, Billie Gibson, Roy Parenti, unidentified, Albert Martin, and Bruno Ricardi; (middle row) Juanita Carrasco, Luise Michele, Antonette Morrow, Mary Murray, Rush Dayen, Jeannie Ferra, Roger Watson, Eddie Rodondi, Mary Lotto, Carl Rolih, Douglas Root, and Attilio Bagani; (back row) Katherine Nichols, Matilda Maggi, Dorothy Lewis, Bessie Holcomb, Dorothy Jean Vaccari, Barbara Gotelli, Caroline Volonte, Eleonore Germano, Leo Lovi, John Tasson, Dennis Dunlop, and teacher Alice Wallace Swanson. (Courtesy of South San Francisco Historical Society.)

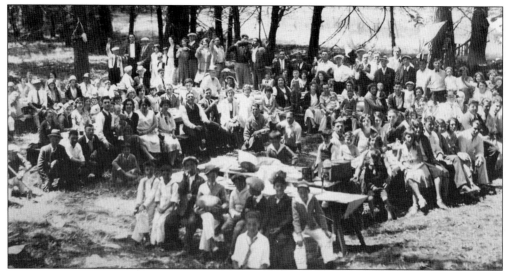

Here is a c. 1937 photo of Societa Lombarda picnicking at Orange Park's "the Willows" area, land that was once owned by the Land Company. South San Francisco learned gradually that the best way to improve the system was to require developers to construct parks when they built the neighborhoods. This lush area was not easy to gain access to because of the thick willow trees. It is said that the Land Company initiated a tree-planting campaign in the 1890s, when the town began. Trees were donated to individuals, and by 1895 more than 1,000 trees had been planted. (Courtesy of South San Francisco Historical Society.)

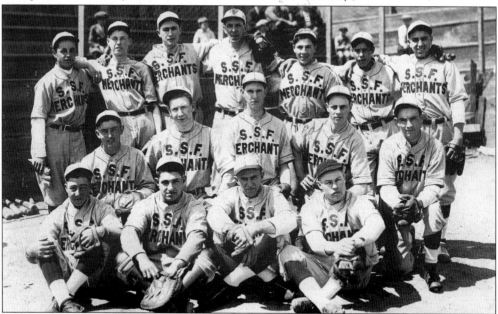

South San Francisco merchants baseball team of 1925 (with Ed Ringue Sr. as manager) was comprised of, from left to right, (front row) George Laufer, Rudy Petrocchi, Stallings, and Carl (Jazz) Welte; (middle row) Adolph Medeghini, George Wallace, Levio Raffaelli, Ed Ringue Sr., and Bud Ring; (back row) Manuel Costa, Walter Welte, "Mud" Mezzetti, Ed Ringue Jr., unidentified, Ernie Merolini, Marvin Menzie, and Henry (Fava) Gaspar. (Courtesy of South San Francisco Historical Society.)

Mr. L.J. and Mrs. Ida Bloom are launching the SS *Sea Angler* on September 27, 1943, built by Western Pipe and Steel. Western Pipe and Steel (which opened in 1913 as Shaw-Batcher Pipe Works and was taken over by United States Steel in 1929) was originally constructed to supply heavy-riveted penstock for PG&E. During World War II, they built 45 ships in 48 months for the Maritime Commission, including CIBs and C3s. The company name changed many times—in 1948 Consolidated Western Steel Company, a division of United States Steel; in 1964 United States Steel, American Bridge Division. The plant became a rolling mill. The steel was made elsewhere and then was sent to this location to be reformed. In 1983 the plant was closed and torn down. (Courtesy of South San Francisco Public Library Local History Collection.)

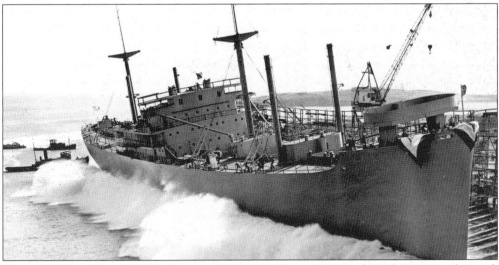

Here is the launching in 1942 of a cargo ship at the Western Pipe and Steel Company shipyard. Although this ship followed original design, many of the ships were converted to troop ships and others to aircraft carriers with only a 500-foot flight deck. A catapult launched airplanes. At launch date ships were far from ready, but a tarpaper fire was built in the funnel to give the illusion of getting up a head of steam. There was only one other shipyard in Louisiana that did sideways launching. Ships were also built in this yard during World War I. During low tide the old ways can still be seen, but are gradually deteriorating. (Courtesy of South San Francisco Historical Society.)

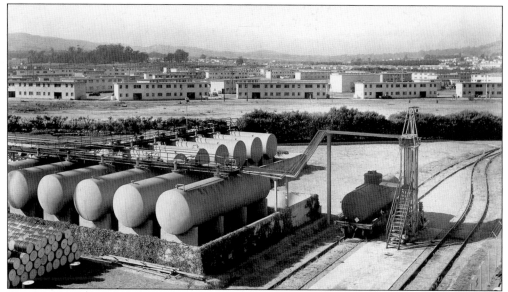

Reichhold Chemical Company (1937–1983), shown here in 1945, manufactured synthetic resins and industrial chemicals that were used by the paint, varnish, lacquer, and printing ink industries. It had the largest storage warehouse on the Pacific Coast. Also located here was a service laboratory to solve the technical problems of paint production. In the background is the Lindenville housing development. It was created during 1943 to fill a desperate need for housing. It was operated by the South San Francisco Housing Authority and demolished in 1958. A more modern development was built on C Street in the 1960s. (Courtesy of the South San Francisco Public Library.)

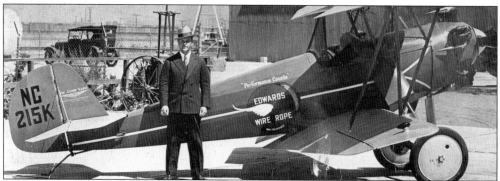

Edwards Wire Rope (1916–1981) head salesman E.H. Edwards is getting ready to leave on the company bi-plane in this c. 1918 photo. Edwards Wire Rope Company manufactured wire cables and fish netting. Many of the products were galvanized at the plant. (Courtesy of South San Francisco Public Library Local History Collection.)

Merck and Company Inc.'s Marine Magnesium Plant was a research-driven pharmaceutical products and services company. In 1943 it bought Marine Magnesium Corporation (manufacturers of Milk of Magnesia). It was located at 500 East Grand Avenue and in 1982 moved to 330 Pt. San Bruno Avenue. The picture below is an aerial view of Merck Chemicals *c.* 1950. (Courtesy of South San Francisco Public Library Local History Collection.)

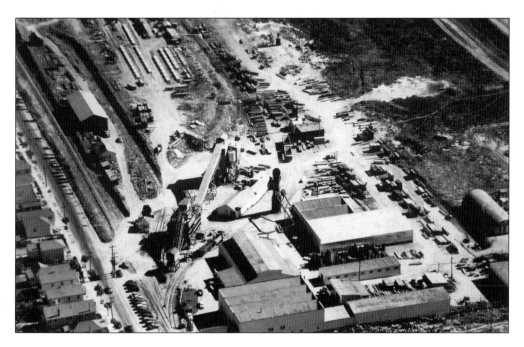

Four
BALANCED COMMUNITY

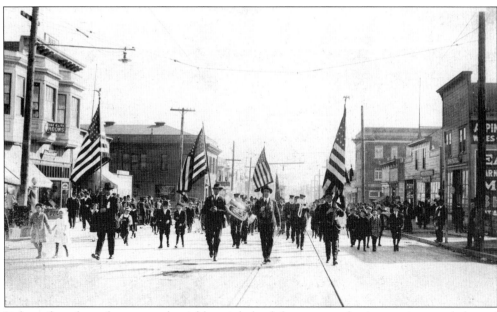

Industry has always been a good neighbor; it helped the town evolve into a vigorous, balanced community with spirit and energy. This 1915 parade was in honor of the grand opening of the Fraternal Hall located at 413 Grand Avenue. The hall was completed in 1915 and all the fraternal organizations participated in financing its construction. The building had a meeting room upstairs and a huge social hall downstairs. Masquerade balls and social dances were continually held there. The building was a collaboration of fraternal organizations that was incorporated on September 9, 1908; the organizations alternated their meeting nights at the facility. Years later the building was bought by Guido Rozzi and was converted to a furniture store; in the 1980s it was renovated by the Croatian Society and returned to a hall and office building. (Courtesy of the South San Francisco Historical Society.)

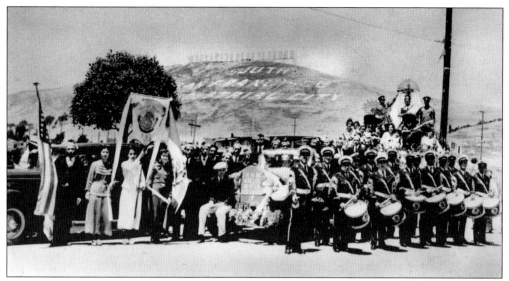

Sociedad Mutualista Mexicana Morelos is a benevolent organization, founded in 1926 to honor Jose Maria Morelos, a great Mexican hero. The society was established to help Mexican immigrants upon their arrival in South San Francisco. Annual parades down Grand Avenue were held, with participants wearing colorful costumes of various provinces as the young ladies clicked their castanets. Following the parade there was always a picnic. In 1964 the society built its own hall at 206 Miller Avenue. (Courtesy of South San Francisco Historical Society.)

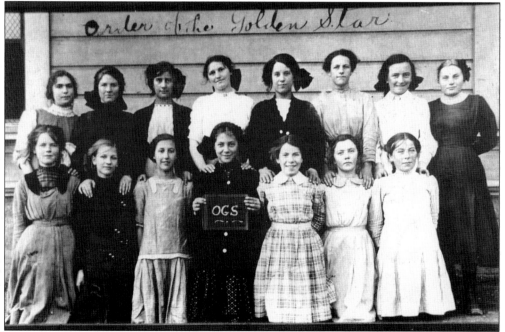

Order of the Golden Star, a fraternal organization, included seventh- and eighth-grade girls. In 1910 the order included, from left to right, (front row) Lucy Fleming, Juanita Dean, Consuela Raspadori, Agnes Karbe, Minnie Foley, Helen Carmody, and Mildred Foley; (back row) Amelie Fourcans, Maude Wallace, Emily Bartoli, Maggie Davis, Edith Bartoli, Dora Schmidt, Mary Carmody, and Annie Kavanaugh (Courtesy of South San Francisco Historical Society.)

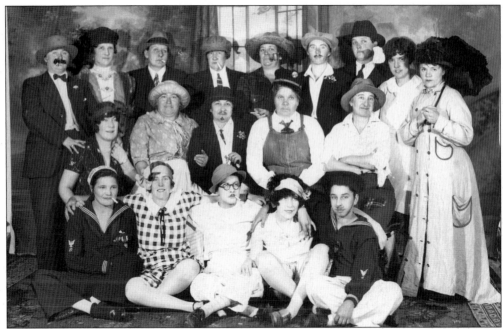

Neighbors of the Woodcraft members in 1923, are from left to right, (front row) E. Lemons Craig, Irene M.D. Signarawitz, Tillie Bernardo, Minnie Foley, and Vivian Gould; (middle row) Mildred Foley, Marie Louise Fourcans, Mary Bernardo, Kate Foley, and Mrs. King; (back row) unidentified, Edith Bartoli Langenbach, Fay Ferron, unidentified, Caroline Holbrook, unidentified, unidentified, Sylvia Thomas, and Irene Lemmons. (Courtesy of South San Francisco Historical Society.)

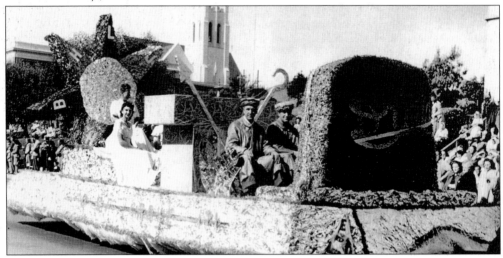

United Ancient Order of the Druids' 1928 parade on Grand Avenue moves past the City Hall viewing stand. Giovanna Penna is the queen sitting with her court. The princess is Joyce Bollazzi. The Druids, an Italian fraternal organization, was founded in 1905 by a group of 16 men who met at the Union Hall. The first Noble Arch was Carlo Guidi and secretary was Peter Mairani. In 1942 the society converted to English. Mrs. Penna, wife of Joe Penna, loved to sing operas and would perform for many organizations, including the Druids, Societa Operaia, and Sons of Italy. (Courtesy of South San Francisco Historical Society.)

Santo Cristo Society, a Portuguese cultural organization, was formed c. 1911. The society is comprised of Portuguese families from nine islands in the Azores. An annual celebration, chamaritas (Portuguese dance), is held on the fifth Sunday after Easter, with a religious service, a parade, a free lunch of "Soupas" served to the general public, and a free dance ending the activities.

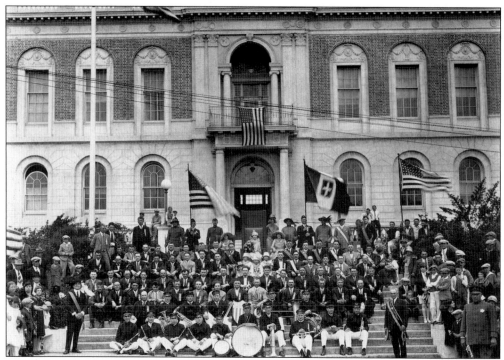

Societa Lombarda was an Italian organization comprised of families that immigrated from Lombardi, Italy, and settled in South San Francisco. The Lombardi dialect, unlike other Italian dialects, is similar to French. Meetings were held at the Fraternal Hall. The 1928 picture includes the South San Francisco Industrial Band, Enrico Rossetti (front left with sash), John Tacchi (front right with sash), and Vince Bianchini, police officer (right front). (Courtesy of South San Francisco Historical Society.)

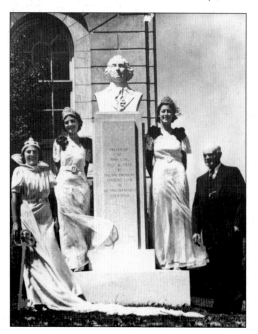

The Italian American Citizens Club was founded in 1916 as a political organization to help Italian immigrants attain citizenship. On July 4, 1936, club president John Tacchi, the IACC queen, and her court presented the city with a bust of George Washington that was placed on a pedestal in front of city hall. The club's first president was Tacchi, vice president Battista Rodondi, and secretary Peter Mairani. (Courtesy of IACC.)

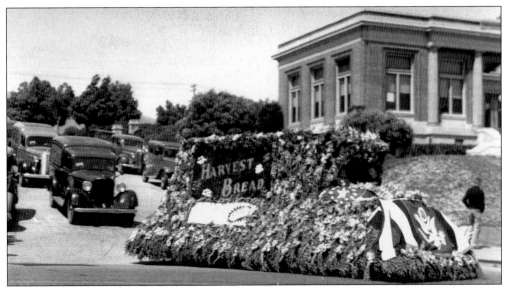

Here the Harvest Bread float is turning the corner at Walnut and Grand Avenues, as it participates in the 1936 IACC parade. Victor Boido of Boido Bakery, who also served as city councilman from 1936 to 1946, owned Harvest Bread. In the background is Carnegie Library, built in 1916, a challenge that Rue Clifford took up in 1914 and won. On horseback, she circulated petitions demanding the city trustees apply for the Carnegie funding. It was the first civic center structure. (Courtesy of IACC.)

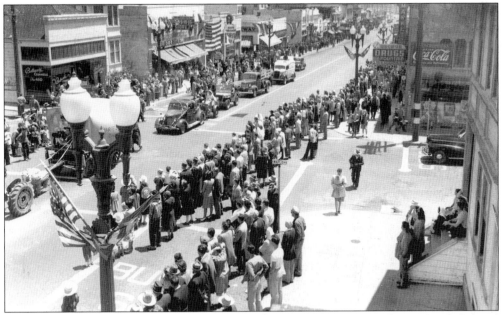

During the 1939 IACC parade up Grand Avenue in celebration of Columbus Day, people lined the street on a breezy sunny day. On the left side of the street at the corner of Grand and Maple is Bettucchi's Laundry and Lucchini's Shoe Repair; heading east on Grand is an apartment building, the Five and Dime Store, Safeway, Santini & Roccucci, and Boido's Bakery; on the right side of the street is Anchor Drug Store, then Vincenzini's Meat Market. This picture was taken from the roof of the *Enterprise Journal* building. (Courtesy of Alvaro Bettucchi.)

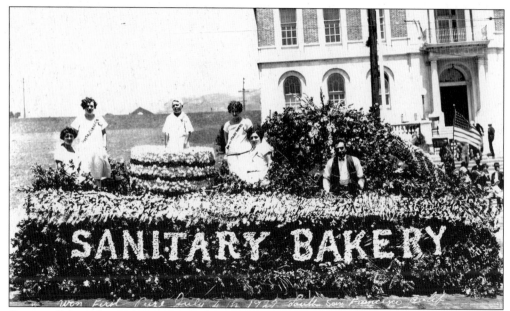

Sanitary Bakery, located at 324 Grand Avenue, participated in the 1927 Fourth of July parade. Employees on board the float include, from left to right, Virginia Bermachi, Alma Brandi, Ambrose Galli (age 10), Annie Baldi, and Eleanore Galli. The float took first place. Five generations of the Galli family have worked at the bakery, which started in South San Francisco in 1909. Current proprietors are Ambrose and Marilyn Galli. (Courtesy of South San Francisco Public Library Local History Collection.)

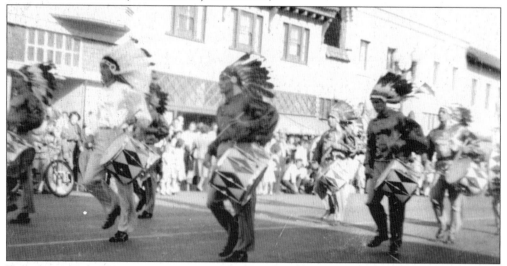

Tippecanoe Tribe No. 111, Improved Order of Redmen, founded in 1901, participates in a 1932 parade up Grand Avenue. The parade is passing F. Giffra's Store at 220 Grand Avenue. The organization held its meetings at the Butchers Hall on Baden Avenue, and members included J.P. Newman, Sachem; H.G. Plymire, Seniore Sagamore; J.B. Wallace, Junior Sagamore; Julius Eikerenkotter, Prophet; J.H. Kelly, Chief of Records; H.J. Vanderbos, Keeper of the Wampum; trustees J.C. Connely, Charles Willin, and R. Gollnick; First Sannap E. Adams; Second Sannap George Apel; Guard of Forest R. Carroll; and Guard of Wigwam A. Lindholm. (Courtesy of South San Francisco Public Library Local History Collection.)

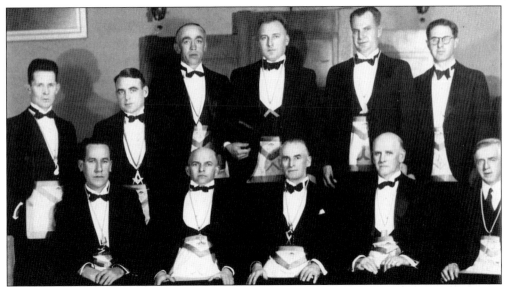

Masonic members of 1935 include, from left to right, (front row) R.E. Woodman, marshal; Adolph Arndt, treasurer; Charles W. King, secretary; G.W. Duncan, chaplin; and William Luty, tyler; (back row) Charles K. Elder, junior standard worthy master; Charles Sellick, junior deacon; Herman Scampini, junior warden W.M.; C.E. Peterson, master; Franklyn A. Dominy, senior warden W.M.; and Raymond L. Spangler, senior deacon W.M. Meetings were held at the Fraternal Hall until the Masonic Hall was built at 307 Grand Avenue during the 1950s. (Courtesy of South San Francisco Historical Society.)

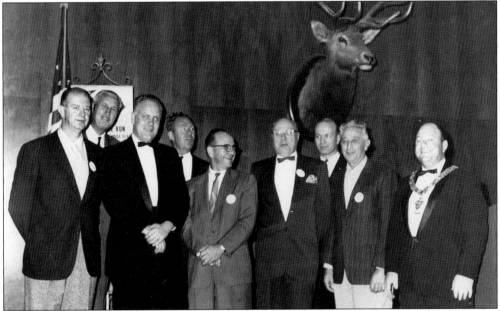

Benevolent Protective Order of the Elks Lodge No. 2091 was formed in 1958. Meetings were held at the Bank of South San Francisco on Grand Avenue and the American Legion Hall in San Bruno until the lodge was built at 920 Stonegate Drive in 1961. The membership totaled more than 800 members. Pictured in 1961 are unidentified members with Fire Chief Al Welte (fourth from left), the club's first exalted ruler. (Courtesy of the South San Francisco Elks.)

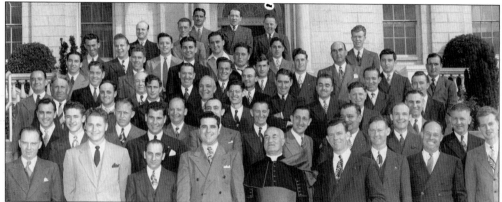

The Young Men's Institute Charter Day celebration in 1946 includes members, from left to right, (first row) Andy Farrell, Al Dimminger, Lucien Caron, Leo Cortesi, Msgr. Tozzi, Shifty Smith (Ignation Council #35), Vincent Felsenthal, Joe Souza, and unidentified; (second row) Peter Maffei, Frank Casagrande, Horace (Doc) Wald, Leo Ferko, Joe Bracco, Jiggs Bonalanza, unidentified, Dick Minucciani, Adolph Sani, Fred Baldasseroni, John Gardner, and Augie Barberis; (third row) unidentified, Joe Martin, unidentified, Cesar Lencioni, Eugene Sunia, Eugene Lynch, Guido Rozzi, Julio Antonelli, Alex Gaddini, and Bill Maher; (fourth row) Emilio Fontana, John Vincent, Dan Hyland, Robert Roccucci, Mario Raffaelli, and Ernest Bonalanza; (fifth row) Chris Ramos, Jerry Quinlan, Rich Manfredi, Bill Doyle, Joe Bertoldi, Joe Ruo, Joe Iskra, Bob Landucci, B.J. Rodondi, Joe Rodondi, Bud Eschelbach, and Reno Milani; (sixth row) Aldo Battistini, Ted Stluka, Mario Pieretti, Marc Senaldi, Mario Santini, and Tom Freeman. (Courtesy of South San Francisco Historical Society.)

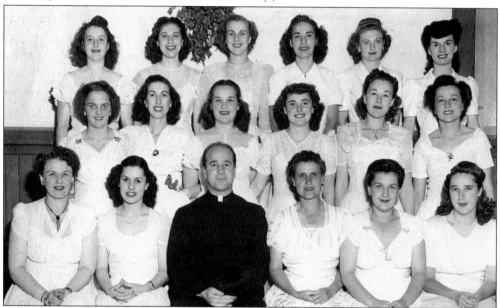

The Catholic Daughters of America and Court "Infant of Prague" members of 1945 are, from left to right, (front row) Kathryn Maloney, state regent; E. Martin; Rev. Lawrence Varni, chaplain; Gertrude Morton, district deputy; Betty Dolwig; and Betty Ottenfield; (middle row) Gloria Belluomini; Mae Lopresti; Adele Cattaneo; Shirley Bertoldi; Lola Schmidt; and Elizabeth Maffei; (back row) Clorinda Roccucci; Mary Lopresti; Val Grassi; Barbara Bisagno; Mary Grassi; and Bernice Monize. (Courtesy of South San Francisco Historical Society.)

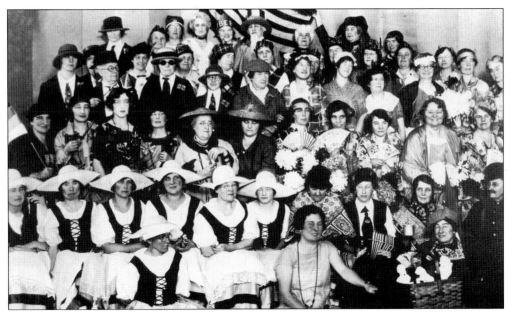

South San Francisco Women's Club members are dressed for 1921's High Jinx, an annual "entertainment" to raise money for the clubhouse fund. Before the clubhouse was built in 1940 at 470 Grand Avenue, meetings were held at the Metropolitan Hall. The club's first president was Marianne Greenleaf Martin, wife of William J. Martin. (Courtesy of South San Francisco Historical Society.)

Dancers gathered in 1992 at Gody Tito's house before their Christmas performance at the Rotary Plaza. Dancers are, from left to right, (front row) Elijah Nicholas, Lani Tito, Frances Valido, and Jason Tejano; (back row) Michael Johnson, Shelley Tito, Jannette Tejano, Yanina Pacis, Genevieve Nicholas, V. Cineres, and Arlene Alcalas. (Courtesy of South San Francisco Public Library Local History Collection.)

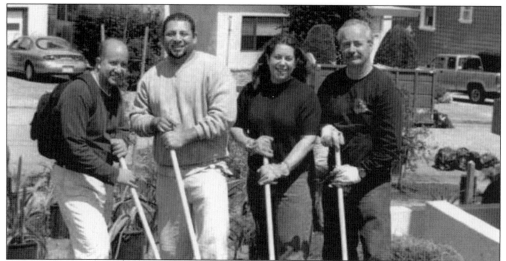

Old Town Homeowners and Renters Association is representative of an area that is still known as Irish Town. Pictured in 2003, from left to right, are Rick Gomez, Edgar Cruz, Lisa DeMattei, and Phil White, working hard to keep the area clean. The first to settle in Irish Town were the Irish butchers and workers who followed Gustuvus Swift & Company to South San Francisco. After the Irish, came the Germans, then Italians, Greeks, and Mexicans, living in peaceful coexistence. Hillside, Airport, Grand, and Spruce Avenues surround the area. (Courtesy of John Wong.)

The 1400 block of Crestwood Drive, located in the Sunshine Gardens neighborhood, is a close knit group of residents that hold an annual block party in 1999 organized by Sheila Gibson (right) with the help of neighbor Emmie Alcancara. Sunshine Gardens was developed during the 1950s as a single-family development, with all the amenities of a suburban neighborhood—wide streets, shopping center, church, schools, and park area. (Courtesy of South San Francisco Public Library Local History Collection.)

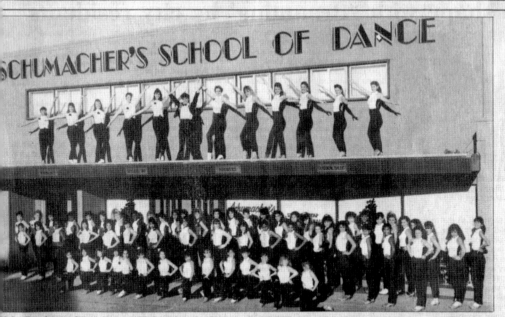

th San Francisco tap dancers Shelley O'Rourke, Dianna James, Wen-James, Kristi Garcia, Janet Villazon, Nancy Griffin, Alison Lum, essa O'Rourke, Andrea Snyder, Maribel Levin, Andrea Silarajs, Jen-Tosetti, Raquel Siordia, Larni Flores, Lani Dibble, Wendy Martens, ka Penn, Jamie Bartels, Cecilia Ruiz, Genevieve Lada, Lisa Wood-k, Tiffany Deang, Amber Achziger, Heather Morch, Jessa Daro, Chara dia, Wendy Angel, Soraya Scharifi, Richelle Sarmiento, Shanda ghn, Audra Carli, Gina Garcia, Erline Sana, Alicia Halliday, Jennifer npo, Shawna Smith, Heather Bollier, April Alex, Alicia Grey, Julie ten, Kristi Kerwin, Katie James, Rowena Ocampo, Maureen McCor-

Regina Bersaglieri, Lisette Macay, Jennifer Luke, Rachel Jamawater, Teresa Woodall, Liana Gonzales, Heather Clark, Vicki Isaak, Monique Walton, Lea Campbell, Dorothy Andres, Sherri Irving, Kristina May, Elisha Padilla, Tina Avelar, Lisa Barsanti, Daniella Winford, Suzie Bar-santi, Brooke Biagi, Leigh Kelly, Katie Kerwin, Michelle Rodriguez, April Vaughn, Michelle Guiney, Vicky Castro, Joana Bones, Jennifer Scheele, Rose Frazier, Priscilla Callero, and Amy Isaak will join other students from Schumacher's Dance School at a performance to publicize national tap day, commemorating the birthday of Boe Jangles. The students will perform with Tap Masters Gregory Hines and Joel Grey at San Francisco

Schmacher's School of Dance, located at 222 Mosswood, is owned by Dolly Schumacher, who co-founded the school with her mother, Dorothy, 40 years ago. It is the oldest family-run dance studio in the state with more than 700 students and 114 classes a week. Dolly taught her first class at the age of 15 for the South San Francisco recreation department. This is part of a 1998 performance celebrating tap dance day commemorating the birthday of Bo Jangels. Students are Shelley O'Rourke, Dianna James, Wendy James, Kristi Garcia, Janet Villazon, Nancy Griffin, Alison Lum, Vanessa O'Rourke, Andrea Snyder, Maribel Levin, Andrea Silarajs, Jenny Tosetti, Raquel Siordia, Larni Flores, Lani Dibble, Wendy Martens, Anika Penn, Jamie Bartels, Cecilia Ruiz, Genevieve Lada, Lisa Woodcock, Tiffany Deang, Amber Achziger, Heather Morch, Jessa Daro, Chara Siordia, Wendy Angel, Soraya Scharifi, Richelle Sarmiento, Shanda Vaughn, Audra Carli, Gina Garcia, Erline Sana, Alicia Halliday, Jennifer Ocampo, Shawna Smith, Heather Bollier, April Alex, Alicia Grey, Julie Wroten, Kristi Kerwin, Katie James, Rowena Ocampo, Maureen McCormack, Gina Ingersoll, Kim Garrett, Melissa Pomper, Angela O'Rourke, Regina Bersaglieri, Lisette Macay, Jennifer Luke, Rachel Jamawater, Teresa Woodall, Liana Gonzales, Heather Clark, Vicki Isaak, Monique Walton, Lea Campell, Dorothy Andres, Sherri Irving, Kristina May, Elisha Padilla, Tina Avelar, Lisa Barsanti, Daniella Winford, Suzie Barsanti, Brooke Biagi, Leigh Kelly, Katie Kerwin, Michelle Rodriguez, April Vaughn, Michelle Guiney, Vicky Castro, Joana Bones, Jennifer Scheele, Rose Frazier, Priscilla Callero, and Amy Isaak. (Courtesy of South San Francisco Historical Society.)

Day in the Park is an annual event occurring each September at Orange Park. The one-day event was created by councilman Joe Fernekes to bring the community together for a fun day entirely free. A car show, farmers market, petting zoo, entertainment, and educational exhibitions are included. Local companies, such as Genentech, See's Candies, Britannia Investments, Myers Development, Hines, and Slough Estates sponsor the event and pay for much of the operating cost. (Courtesy of John Wong.)

Ballet Folklorico Infantil of South San Francisco performs at Day in the Park in 2002. Dancers, from left to right, are Clarissa Pulido, Jacqueline Gonzalez, Chenea Pulido, Danielle Rosales, Cecelia Vieyra, and Michelle Chan. The group started in 1985 with the recreation department, performing at no cost throughout the community. Rosa Yniguez Perez is the director and is a volunteer instructor. (Courtesy of G. Haro.)

Alta Loma Park, located at 450 Camaritas Avenue, was completed in 2002. The youth field was dedicated to Ermen Rozzi in 2000 for his commitment to managing youth baseball teams for 20 years and raising thousands of dollars for sports programs. The north field was dedicated to Gus Nicolopulos in 2003, as founder of the South San Francisco police athletic league and for his dedication to youth baseball. (Courtesy of South San Francisco Historical Society.)

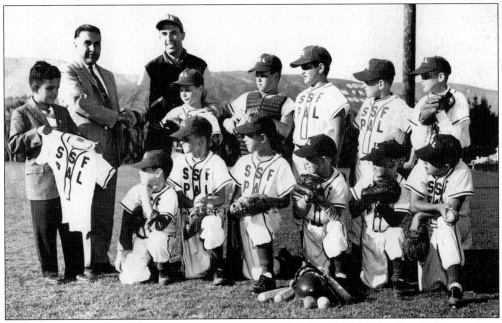

Gus Nicolopulos (third from left) is shaking hands with Silva as PAL's first baseball team starts its 1958 season. Gus served as the organization's president for seven years. Among those shown are Steve Rozzi, Ron Lombardi, Joe Rajiski, Clay Davis, Neil Barberis, Rory Fischer, and Tommy Davis. Nicolopulos was a sergeant in South San Francisco police department and became a councilmember upon retirement. (Courtesy of Diane Green.)

Here is the 1947 Windbreaker team that outscored their opposition by a total of 205 points to 76. These men, although each and every one had a day job, appeared at every practice session immediately after dinner and spent countless hours in the betterment of the club, the Windbreaker Athletic Club. (Courtesy of the South San Francisco Historical Society.)

The Bob Brian baseball field (pictured in 2004) was dedicated at Orange Memorial Park on April 10, 1993, in recognition of Brian's commitment to youth in organizing the South San Francisco Pee Wee Baseball League in 1960. Sharing the same turf is the Archie Fregosi field that was dedicated on April 25, 2000, in memory of Fregosi's love for coaching and sponsoring little league teams. Fregosi owned Ted and Archie's Market on Linden Avenue and later Fregosi's Market on Baden Avenue. He was a lifelong fan of baseball and his son Jim Fregosi was a successful major league baseball player and manager. (Courtesy of South San Francisco Historical Society.)

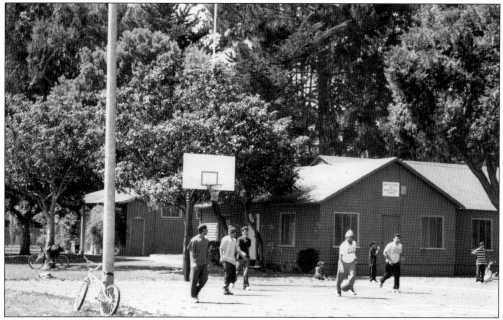

The Orange Memorial Park log cabin was built in 1937–1938 for the Boy Scouts as a clubhouse; the organization had been meeting previously at the Fraternal Hall. In later years the community used the building for recreational purposes. The basketball courts area, located between the log cabin and recreation building, are constantly used by teenagers and adults, with two or three games going at once. (Courtesy of South San Francisco Historical Society.)

Rick Ochsenhirt, Mario Scalettti, Angeleno Scrivani, and Alda Scaletti participate in a Saturday morning bocce tournament at Orange Memorial Park in 2004. The courts were completed in 1990 as a joint effort between the city and the Italian American Citizens Club. A simple two-lane court existed prior to this time, but due to the popularity of the sport and its social aspects, the area expanded, lights were installed for night play, a club trailer was assembled, and covered courts were added to the area of the horse shoe pits. The IACC holds tournaments, and offers lessons and league play throughout the year. (Courtesy of the South San Francisco Historical Society.)

Watching the antics of a clown on stilts at a city celebration, from left to right, are Annie Eli, Eldie Gonzalez, Ida Penna, and Delia Ramos. The Orange Memorial Park playground renovation was celebrated in 1998 along with other playgrounds located at Brentwood Park, Paradise Valley, Sellick Park, and Gardiner Avenue Park. The 20 acres that comprise Orange Park was a gift from the Land & Improvement Company in 1925. The area known as the Willows was given with the proviso that the Land & Improvement Company be allowed to build a road on both sides of the park and that all street paving necessary in the future be paid for by the city. (Courtesy of John Wong.)

The pathway extends the recreational use of Orange Park by providing a passive link, fronting Colma Creek, to accommodate walkers, joggers, and bicyclists between Orange Avenue and South Spruce Avenue. The park was officially named Sister City Linear Park in 2000 and sister city flags are flown for visiting delegates. (Courtesy of Mike Lappen.)

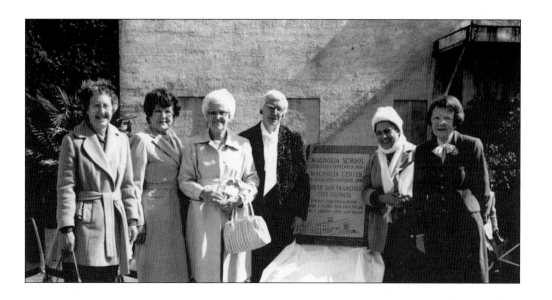

Attending the Magnolia Senior Center groundbreaking ceremony in October 1986, from left to right, are Edna Harks, Alice (Uccelli) Marsili, Margherete (Cavassa) Westh, Elizabeth (Lautze) Ervin, Evelyn Martin, and Lura Sellick. The building, located at 601 Grand Avenue, was formerly the site of Magnolia School, built in 1925 by local contractor Richard Stickle. The nursery-rhyme murals that were once displayed in the kindergarten classroom are now hung in the center's community room. Next door was the site of Grand Avenue School, built in 1907 to replace the aging Baden Avenue School, built in 1885. Grand Avenue School was demolished in 1954. In its place today is Magnolia Plaza, a 125-unit senior apartment community that had its grand opening on September 12, 1987. (Courtesy of John Wong.)

The Westborough Recreation Building, dedicated June 1988, was a long-awaited facility for the Westborough area. It was constructed by Echo West and designed by Group 4 Architecture. The building is used for recreation classes, childcare, and includes a community room. The Westborough Park Steering Committee included residents Alice Bulos, Caesar Churchwell, Lois Jackson, Gerald Simotas, Barbara Sperring, Charles Theiss, and Albert and Anne Waters. (Courtesy of John Wong.)

The Westborough Junior High School Band and cheerleaders performed at the dedication ceremony of the Westborough Park Building on September 24, 1988. Bands have always been a part South San Francisco's history dating back to the Western Meat Company's Band. Other bands that were local favorites were the South San Francisco Industrial Band, Charlie Bolazzi's Band, Minucciani's Band, Tippicanoe Drum Corps, and the Windbreakers Drum Corps. (Courtesy of John Wong.)

Alice Bulos (pictured in 1998 with an unidentified gentleman) is a Westborough resident and activist for the Filipino community. She has been given numerous awards for her volunteer and community service. Born in the Philippines, Alice was chairperson of the department of sociology at the University of Santo Tomas in Manila. She was named Woman of the Year in 1987 by the Pacific Asian Women Bay Area Coalition and inducted into the San Mateo County Hall of Fame in 1988. (Courtesy of John Wong.)

Westborough's Sellick Park honors two distinguished citizens, Lura Sellick and Carrie Winterhalter. The facility is dedicated to Lura, a chartered member of the Parks and Recreation Commission for 45 years. She was an active participant in the development of all recreation facilities of the City. On September 21, 1983, the play area (pictured) was dedicated in memory of Carrie Winterhalter, a resident of 415 Grand Avenue from 1908 to 1932. She was an advocate of many town improvements that were realized in her time, such as the supervised summer playground program, the first Easter egg hunt, a living Christmas tree at civic center, and an electrolier lighting system for the downtown area. (Courtesy of South San Francisco Historical Society.)

Grace Martin Barton, daughter of William J. Martin, poses *c*. 1915 in a field of wild irises, South San Francisco's designated flower. It is said that children would pick the flowers and sell them on Bayshore Boulevard to passing motorists for pocket money, and that the constant gathering led to their eventual disappearance. (Courtesy of South San Francisco Historical Society.)

At the entrance to Sign Hill, volunteers are getting organized to make the journey up the hillside to plant trees at the annual Arbor Day celebration. Rich Bordi (pictured center in 1994) was the city's superintendent of parks for many years and always participated in the event. Mr. Alphonse Seubert, a longtime beautification committee member, initiated the first planting. He has received much recognition for his contributions and dedication to enhance the quality of life in South San Francisco. (Courtesy of John Wong.)

This view in 1989 of the south slope of San Bruno Mountain and the once controversial Terrabay Development is seen from the top of Sign Hill. Numerous lawsuits prevented the development from being built due to ancient Indian midden sites. Rebecca Payne is enjoying a peaceful moment before trekking back down the hillside. Terrabay is the last big multi-use development in South San Francisco. The city's population is projected to increase by 21 percent between 1990 and 2020 from 57,608 to 69,900. (Courtesy of South San Francisco Public Library Local History Collection.)

The Terrabay Gymnasium and Recreation Center is at the entrance to the Terrabay development along Sister Cities Boulevard. The center includes an indoor basketball court, an exercise room, meeting rooms, and kitchen facility. Sitting facing the camera is Shirley Nichols and Dave Carelli enjoying the outdoor dining on grand opening day, 1998. In the background is the dedicated open-space area of Sign Hill's north side. (Courtesy of John Wong.)

The Ladies Annual Christmas Luncheon for city employees, this one in 1988, has been a tradition since the 1960s. First organized by Finance Department employee Louise (Rostoni) Coleman, it was annually held at the California Golf Club. The golf course was established in 1926 at 925 El Camino as a private club and then the entrance was moved to 844 West Orange Avenue. Pictured, from left to right, are (front row) Victoria Morales Healy, Muriel Mermon, Esther Flores, Pauline Marx, Letty Beard, unidentified, Sylvia Payne, Beverly Chavis, Dorothy Buhagiar, unidentified, Marge Vidak, and Barbara Battaya; (middle row) Gloria Taormina, Olga Perez, unidentified, Sharon Ranals, Rose Parks, Susy Kalkin, Jean Sprouse, Mary Guisti, Dee Urtin, Charito Antaran, Mary O'Nyon, Teiko Itzusu, Zita Cussary, Phyllis Feudale, Rosa Freddie, Connie Camacho, and Sue Harris; (back row) Carolie Gibson, Elledene Katz, Theresa Ingram, unidentified, Helen Kim, Helen Mira, Wenda Da Cunha, Maureen Morton, Lydia Tolmacheff, Jeanette Acosta, Mary Metcalf, unidentified, Marilyn Peters, Jean Smith, Dana Cesca, Roberta Teglia, Valerie Armento, Zona Volosing, and Stella Huey. (Courtesy of S. Payne.)

Recreation and Community Services Department staff coordinate the everyday recreational activities for residents that include senior programs, child and senior day care, swimming, organized sports, and a varied program of special classes. Here, in 1998, supervisors and support staff have gathered in the MSB Atrium. From left to right are (front row) Kelli-Jo Cullinan, Melanie Tan, Susan Filereto, Wenda daCunha, and Sharon Ranals; (back row) Sue Pierotti, Barry Nagel, Sandy Dugan, Sylvia Payne, Elaine Porter, Gus Vellis, Joe Hunziker, Tim Chenette, and John Wong. (Courtesy of John Wong.)

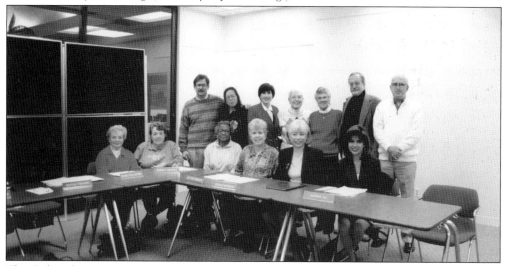

The Cultural Arts Commission was formed in 1994. and with a creative approach to funding, they have realized significant achievements such as the murals, sculptures, and landscape upgrades throughout the city. This 1995 picture was taken in the MSB Betty Weber Room. Members include, from left to right, (seated) Elsie Pollastrini, Shirley Nichols, Ann Waters, Joy-Ann Wendler, Karyl Matsumoto, and Glenda Ali; (standing) Dennis Crossland, Elizabeth Nisperos, Alicia Gonzalez, Barbara DeMattei, Maggie Pierson, Ron Burgess, and Jack Drago. (Courtesy of John Wong.)

The Wind Harp was constructed in 1967. The tower was originally commissioned as a focal point for the Cabot, Cabot & Forbes Industrial Park. Designed by artist Aristedes Demedtrios, it rises 92 feet. It is fabricated from steel manufactured at Bethlehem Steel. It was designed to "take advantage of the viewer's motion . . . constantly changing, presenting a series of graceful ellipses and a shifting light pattern." The sculpture was acquired by the city in 1996 and rededicated on March 28, 1997, in memory of Jake Jones, who promoted the city's acquisition and refurbishing of the Wind Harp. (Courtesy of John Wong.)

Five

20TH-CENTURY LEADERS

From the time South San Francisco was part of a Spanish land grant to its status as a 20th-century municipality, settlers came from distant lands to start a new life. One of the early settlers was Edna (Spangler) Harks, a resident since 1917. A neighborhood group, including Edna (seven years old) gathers in 1923 on the Spangler lawn, at 210 Eucalyptus Avenue. Edna was recognized for her community involvement and civic pride. She served on the Historic Preservation Commission and was president of the historical society. It was through her tireless efforts that Sign Hill was listed on the National Register of Historic Landmarks. The Peck House (left) and Martin House (center) are shown in the background. (Courtesy of the South San Francisco Public Library.)

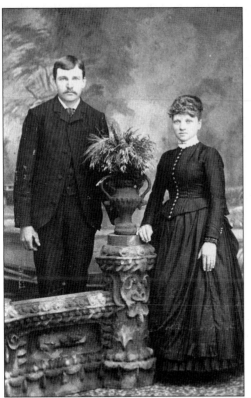

George and Margaret Keissling (pictured in 1910) came to South San Francisco in 1899 from Danville, California when George was seeking employment. They lived at the rear of 329 Miller Avenue with their two sons, George and Sam, and three daughters, Fern (Bowler), Myrtle (Snyder), and Marguerite (Record). The three Keissling daughters became schoolteachers. Fern taught for 40 years in South San Francisco schools, always active in civic organizations, and was proclaimed a "living historian." (Courtesy of South San Francisco Historical Society.)

Sam Kiessling rides the town's first motorcycle in 1911. Kiessling was a volunteer with the police department and was often jokingly referred to as the first motorcycle policeman. The Kiesslings were a longtime South San Francisco family living on Miller Avenue. Sam Kiessling's two sisters were teachers at the Grand Avenue School. (Courtesy of South San Francisco Historical Society.)

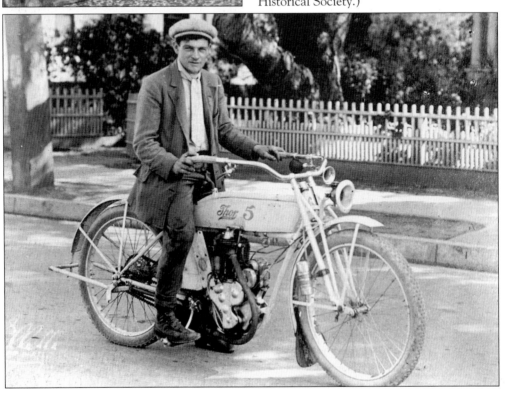

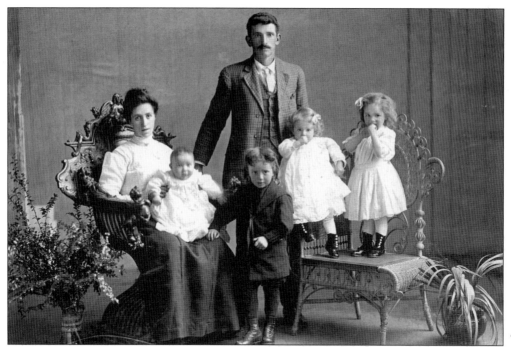

Peter Uccelli (standing in this 1911 photo) migrated from Italy in 1907 when his Uncle Joseph sent for him to help farm violets on the land that he purchased upon his arrival in 1894; the land was located at the west end of Grand Avenue near Willow Avenue. As Joseph's violet-growing business prospered, other nephews, Giuseppe and Giovanni, were sent for, but they made the decision to grow vegetables on land they purchased near their Uncle Joseph. Three acres were purchased along Oak Avenue; the brothers moved the Red Barn from the former Lux Ranch (Commercial and Chestnut Avenues) to the Uccelli property at 150 Oak Avenue, with the aid of horses and rollers in the 1920s. Farming was hard work that left little time for community life, except for an occasional picnic or social gathering. Pictured are Mary and Peter Uccelli with their children, from left to right, George, John, Leonore, and Angelina. (Courtesy of South San Francisco Historical Society.)

Battista Rodondi married Rose Medica in 1912. Their family included Arthur, Andrew, Joseph, Edward, Battista Jr., Olga, and Rosemarie. Battista was born in Brescia, Italy, arrived in South San Francisco in 1908, and worked at Steiger Terra Cotta Works until 1915 when he took work with the Enterprise Foundry. With the guidance of E.C. Peck, Land & Improvement Company, he gained real estate experience and opened his own real estate/insurance business, which seemed to be his forte. Eventually his five sons joined him at B.J. Rodondi Insurance. He was active in many fraternal organizations, including the chamber of commerce and the city's first school board. (Courtesy of South San Francisco Historical Society.)

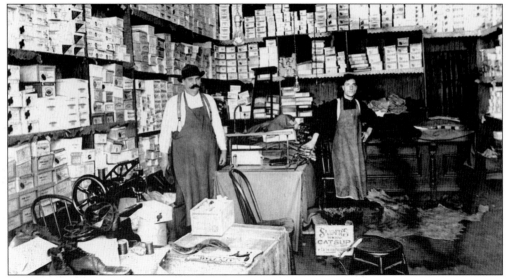

The Bortoli Shoe Store, located at 381 Grand Avenue, was owned by Giovanni (John) Bortoli. Here in 1910 is Mr. Bortoli (left) with an unidentified employee. Unlike today, the number of shoes a person owned in 1910 was limited to one or two pairs. Mr. Bortoli made the shoes on site. The Bortoli family were early settlers in South San Francisco and Giovanni's brothers Dan and Luigi (Louis) were also town merchants. Louis owned a liquor store at 216 Grand and then later at 206 Grand Avenue; Dan owned a shoe cobbler shop on Baden Avenue. (Courtesy of South San Francisco Public Library Local History Collection.)

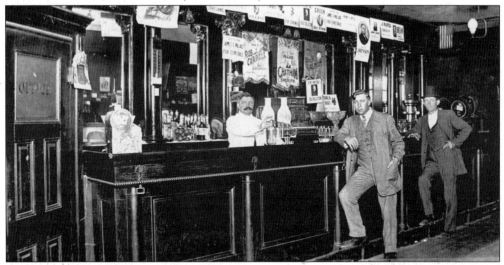

The Union Hotel and Saloon was established in the early 1900s at 222–224 Grand Avenue, and the proprietor was J. Pardini. The bartender, the man with cigar, is Gene Pardini. Patrons, from left to right, are unidentified, Ed Zarro, B. Taylor, and Ned Taylor. Years later the bar turned into Pete's Coffee Shop, owned by two different Petes—Pete Dress and Peter Sargent. Under new ownership in the 1970s, the hotel portion started deteriorating, but the restaurant continued and was renamed the Sundial Café in the 1980s. When a fire occurred in the early 1990s, the city became involved and worked with Mid-Peninsula Housing Coalition to purchase the property and rehabilitate the hotel. Carmelo Iacolino opened Ristorante Buon Gusto in 1990. (Courtesy of South San Francisco Public Library Local History Collection.)

Here in 1910 are two brothers sharing a bottle of wine and another with a shotgun barrel over his shoulder, while posing on the steps of their Commercial Avenue home. Family members include (clockwise from bottom left) Emmanuele Ghilardi, Labindo Mazzante, Enrico Ghilardi, Stella Ghilardi, Ernest Ghilardi, Rosi Ghilardi, Charles Ghilardi, and Frank Ghilardi. (Courtesy of C. Ghilardi-Green.)

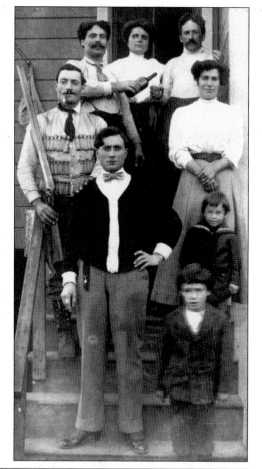

Boulevard Grocery, located at 1051 Airport Boulevard (formerly San Bruno Road), was established in 1928. In 1933 the business was purchased by Emilio Cortesi (pictured with delivery truck), and he operated it until 1967. Cortesi was elected councilman in 1948 and became mayor in 1952. In the 1980s the store was renamed Jailhouse Deli. (Courtesy of South San Francisco Public Library Local History Collection.)

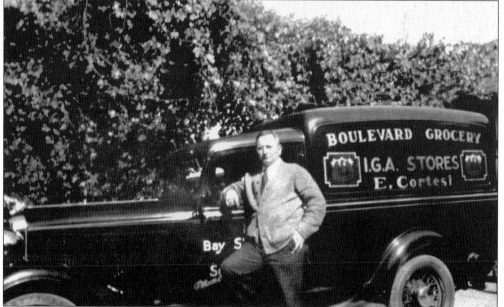

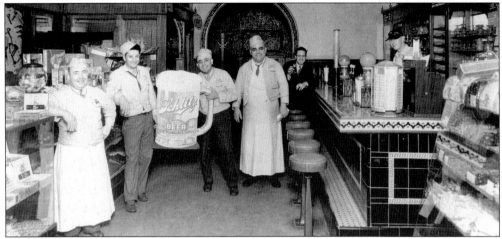

The Tasty Sweet Shop, located at 301 Grand Avenue and owned by the Russo Brothers, was right around the corner from the State Theater and a favorite place to go for candy and ice cream confections, among other items. The store was in business from 1929 to 1941 and the picture shows the owners and employees with a large advertising sign. (Courtesy of South San Francisco Public Library Local History Collection.)

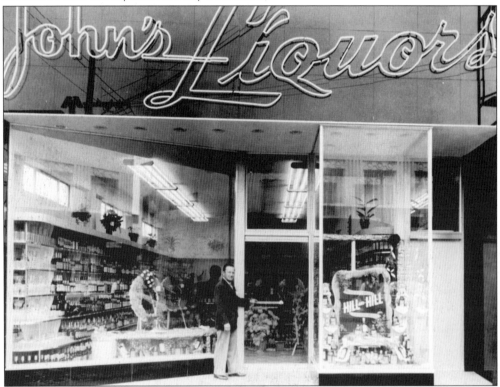

John Penna, co-owner of John's Liquors, located at 310 Linden Avenue, is seen in 1948 opening the family-owned liquor store, initially named Linden Avenue Liquors and located on the opposite side of the street. The original proprietors were Nella (Lombardi) Penna and her sister Annie Baldi, the city's first female-owned enterprise. (Courtesy of South San Francisco Public Library Local History Collection.)

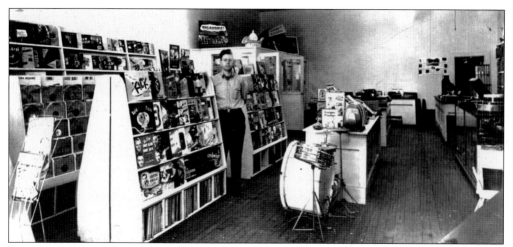

Bronstein's Music Store, owned by Milton (pictured) and Celia Bronstein, was originally established at 224 Grand Avenue in 1946. In 1952 it relocated to 230 Grand Avenue and one year later to a much larger location at 363 Grand Avenue, where the business continues to operate today under the ownership of Don Edwards and Richard Welker. Mrs. Bronstein still remains the property owner. Children and adults come from all over the Bay Area to take their music lessons here or to purchase instruments. The building includes classrooms and recitals are held for proud parents. (Courtesy of South San Francisco Public Library Local History Collection.)

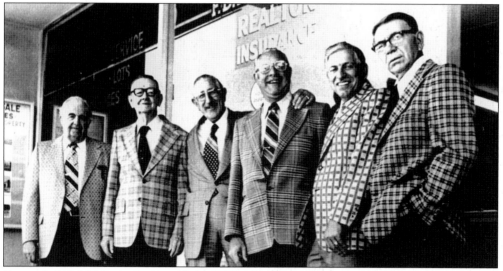

Fernando "Dick" Minucciani established F.D. Minucciani Realty and Insurance, located at 419 Grand Avenue, in 1947. This photo shows, from left to right, Albert Baldi, realtor and office manager; Frank McDonald, realtor; F.D. (Dick) Minucciani, owner; Luther "Lucky" Smith, realtor; Bruno Fanucchi, realtor; and Mario Cutrifelli, realtor. In 1989, Minucciani's became a Farmers Insurance agency, operated by Dick's nephew John Helfrich, son of Dolly Minucciani. Dick Minucciani was said to be a very generous and honest man; if he felt a house was beyond your means he would tell you. When his daughter married he invited the entire South San Francisco community to the reception at Tanforan, and when a fire destroyed All Souls Church he offered to pay for a brand new one. He was also said to have beautiful penmanship. (Courtesy of South San Francisco Public Library.)

Lathan Brake Shoe Company, located at South Linden and Tanforan Avenues, was established c. 1930 and was next door to American Brake Shoe and Foundry at 54 Tanforan Avenue. This picture depicts a fire department demonstration with Fire Chief Alex Welte observing. From left to right are Chief Welte, unidentified, and Mayor Albert Eschelbach. (Courtesy of South San Francisco Public Library Local History Collection.)

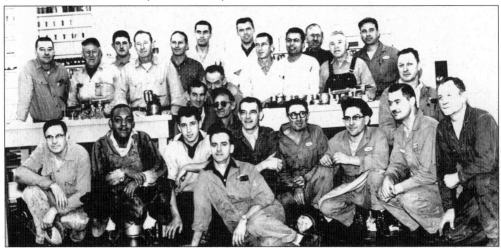

Sun Chemical Company, at 20 South Linden Avenue, bought George H. Morrill Company, which was established in 1927 as an ink manufacturing plant, and continued the business until 1978. Morrill Ink introduced a radical new process-colored ink. In 1950 General Ink Company bought it as part of the Pacific Coast Division. From 1965 to 1978 it was General Printing Ink, a division of Sun Chemical Company. Employees in 1962 included (row two, third from left) Ernest Bortoli and (second from right) Guido Conti. A portion of the site was sold in 1974 to the city to build the Linden Avenue Bridge over Colma Creek. The building was later demolished because of contamination. (Courtesy of South San Francisco Public Library Local History Collection.)

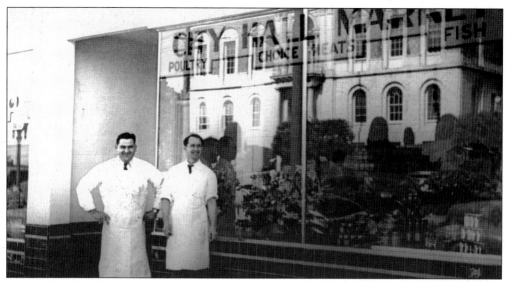

City Hall Meat Market, located at 423¹/₂ Grand Avenue, was operated by butchers Silvio Veglia and Ed Zaro (pictured in 1950). Mr. Zaro learned the trade from Pete Lind of Lind's Market; he later became sole owner of the market until he retired in 1965. A lifelong resident of South San Francisco, Mr. Zaro is a historian, documenting the everyday life of the city for the historical society and is currently writing a book on the history of the downtown merchants. City Hall is reflected in the store window. (Courtesy of South San Francisco Public Library Local History Collection.)

Frank Giffra Store, located at 240 Grand Avenue, was a family business that Frank and his wife Catherine established in 1908. It is the oldest continuing business in South City. Their children inherited the business as a partnership and sons Arthur and Richard maintained its old-time atmosphere, antique counters, and light fixtures, selling hardware and liquor. The property holdings include 240–246 Grand and, in the 1940s, the Duck Pin Bowling Alley was located on the property. Pictured in 1980 are, from left to right, Mario, unidentified, Arthur, Mary, Rena, and Centina Giffra. (Courtesy of South San Francisco Public Library Local History Collection.)

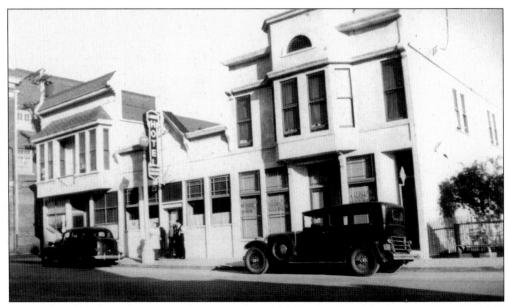

Across the alley from the Metropolitan Hotel was the Linden Hotel built in 1893, at 206–210 Linden Avenue. It included a shaving parlor, a confectionary shop, and a saloon. The original owner was H.G. Vandenbos (c. 1900). Other owners included Wolgaven & Fenger (c. 1912), Ghilardi and Angiolini (c. 1920); the Ghilardi and Mainani families (1923–1931), who changed the name to Hotel Firenze; and the Colombo family (1931–1951). In 1962 the building was demolished and a United California Bank was built. The city purchased the building in 1996 to house city offices. (Courtesy of South San Francisco Public Library Local History Collection.)

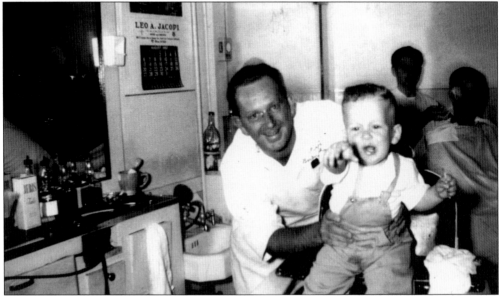

In this 1950 photo, barber Zeppy Bildhauer gives Bruce Tognetti his first haircut. Bruce had a distinguished career in law enforcement, as a police lieutenant for South San Francisco Police Department and, later, Colma's chief of police. (Courtesy of South San Francisco Public Library Local History Collection.)

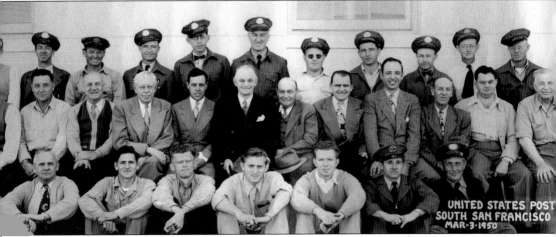

UNITED STATES POST
SOUTH SAN FRANCISCO
MAR-3-1950

The South San Francisco Post Office was established on April 11, 1892. It had several locations until the historic building at 322 Linden Avenue was built during the 1940s. The first postmaster was Ebenezer Cunningham. Postal employees gathered on March 3, 1950, in celebration of the retirement of Postmaster Joseph Quinlan. Pictured, from left to right, are (front row) Ben Hjerpe, Paul Norwood, Mike Krkoska, Bruno Crocciani, Emmet McCourt, Vasco Barsanti, and Maurice O'Brien; (middle row) John Figoni, Sherman Penney, Harold Larsen, William Titmas, Virgil Ringue, Joseph Quinlan, Herman Weller, Victor Ozor, Arthur Wyant, Fred Schmidt, Marvin Steele, and Roland Boldt; (back row) Lowell Wagner, Edward Bergeron, Nick Babich, Earl Sims, Robert Morgan, Paul Trudrung, Peter Selaya, Reno Milani, Joseph Schwartz, Frank McDonnell, Roland Rich, and Joseph Babich. (Courtesy of South San Francisco Historical Society.)

Tisbe (Mama) Bertolucci (center below), originally from Lucca, Italy, migrated to San Francisco at the age of 19, where she met Joe, who owned a clothing store and nightclub in the Excelsior District. In 1928 Mama and Joe became the proprietors of the Liberty Hotel and boarding house at 419 Cypress Avenue that was then run by August Bertolucci. When Prohibition ended, Joe's Blue Room opened. Mama did the cooking with an Old World discipline, in great quantity and quality. In 1962 the restaurant was added at 421 Cypress (pictured c. 1990 above), with children Larry and Lola aboard to help. Mama has been recognized by many dignitaries and been given many awards. She is pictured below with family members Mrs. Larry Bertolucci, Lola Bertolucci Fox, Larry Bertolucci, and Charlie Fox. (Courtesy of Lola Bertolucci Fox.)

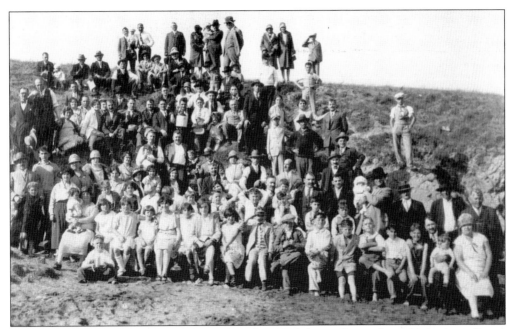

Here is the entire Greek community gathered c. 1931 for an Easter Sunday picnic at Oyster Point. Many Greek families settled in South San Francisco, particularly in Irish Town, and their businesses included Gellepis Bakery, Xerogeanes Grocery and the Nicolopulos Superior Steam Laundry, and Oxford Hotel. Other Greek families included Balopulos, Marefos, Dress, Yeatrakis, Gonis, and Dilles. One Greek boy, James Dilles, wrote "The Good Thief," which told the story of growing up in Irish Town during the Depression years. (Courtesy of South San Francisco Historical Society.)

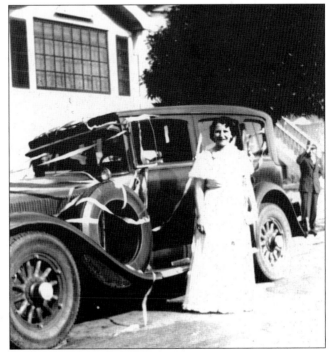

Here is Catherine Dress in 1936 as the Koumbara for Anne and John Pronos on their wedding day. The picture was taken at the Pronos home on Baden Avenue. A Koumbara, the best woman, is a Greek custom; she helps dress the bride, escorts her to the wedding, performs the crowning of the bride and groom and the exchange of rings. (Courtesy of South San Francisco Public Library Local History Collection.)

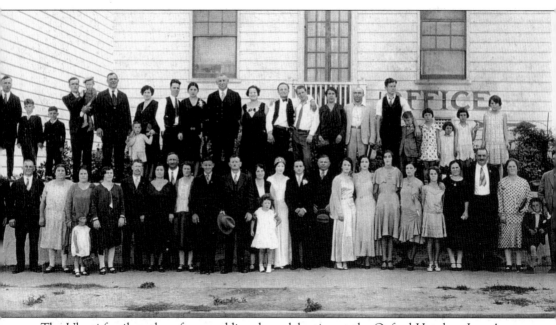

The Uberti family gathers for a wedding day celebration at the Oxford Hotel on Lux Avenue. The family emigrated from Piemonte Italy and many family members settled in the Irish Town area. Pictured c. 1925, from left to right, are (front row) Steve Garbarino, Paulo Tocchini, Magula Garbarino, Anselmina Uberti, Mary Uberti, Leticia (Ruffino) Tocchini, Carlo Bracco, Magdalena (Uberti) Bracco, Giaccomo Barberis, Caterina (Uberti) Barberis, Augustino Barberis, Vincenzo Uberti, Ermalinda (Rolli) Uberti, Rena (Uberti) Isch, Delia (Uberti) Vanni (bride), Reno Vanni (groom), Vanni, Mary (Uberti) Laufer, Blanche (Uberti) Patrone, Eleanor (Barberis) Davis, Rose (Garbarino) Warren, Annie (Barberis) Paganucci, Margherita (Uberti) Barberis, Domenico Barberis, Maria (Uberti) Belvini, Johnny Belvini, and Roberto Belvini; (back row) unidentified Fontana, Paul Fontana, Alfie Fontana, Michael Umbert, Roy Garbarino, Cesara Bracco, Edward Fontana, James Troy, Freida (Bracco) Troy, Guiseppe Penna, Giovanna Penna, John Penna, Victor Bellone, Marietta Simontocchi, Charlie Simontocchi, Johnny Bellone, Reno Penna, Delia (Garbarino) Ramos, Annie (Uberti) Eli, Chensa (Uberti) Curti, and Alice (Garbarino) Ekstrom. (Courtesy of Diane Green.)

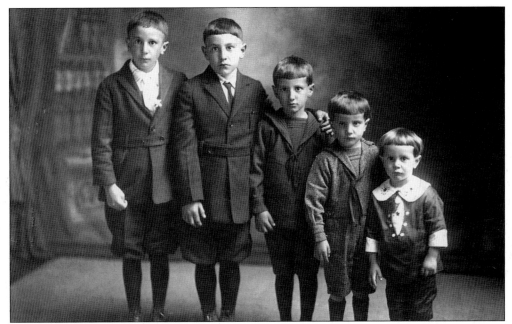

The DeZordo family moved to South San Francisco from Illinois and lived on Baden Avenue. Here in 1925 are brothers, from left to right, Alio, Celso (Chelso), Dini, Levio, and Marcello (Tut). Alio, Levio, and Marcello served in the military during World War II. Afterward, Celso and Tut worked for Edwards Wire Rope, Levio worked at Dupont (paint manufacturing plant), Dini was a contractor, and Alio was a warehouseman. (Courtesy of South San Francisco Historical Society.)

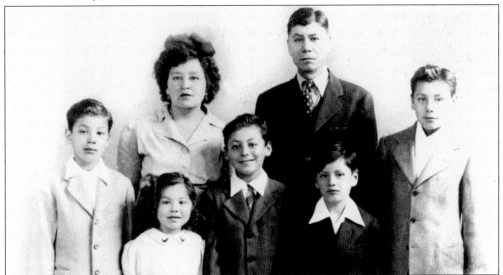

Lupe and Ysmail Gutierrez, Mexican immigrants, are pictured in 1945 with five of their nine children, from left to right, Joey, Carmen, Johnny, Tony, and Andre. This picture was sent to son Cruz Gutierrez while he was serving in the Navy and stationed in the Pacific. Many Mexican and Spanish families settled in the Irish Town area and included the Garcia, Herrero, Ruiz, Villanueva, Perez, Bilbao, Ron, and Yglesias families. (Courtesy of the South San Francisco Public Library.)

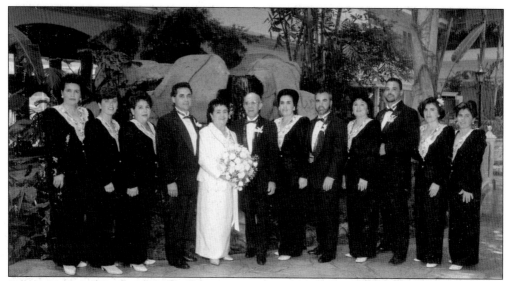

Socorro and Aurelio Yniguez settled in South San Francisco in 1966 and bought a home on Hillside Boulevard that soon needed an addition. He worked for Standard Builders Construction Company for many years. On the occasion of their 50th wedding anniversary in 1994, their children helped celebrate the occasion with a huge party at Embassy Suites. Pictured are Mr. and Mrs Yniguez with their 10 children, from left to right, Socorro (Coco), Alma, Maria de Jesus, Martin, Socorro (Mama Coco), Aurelio, Gracia, Ramon, Leticia, Aurelio Jr., Lourdes, and Rosa. (Courtesy of the Yniguez family.)

Ed Zaro and Levia (Coruccini) Mangini, both born in South San Francisco and longtime residents of B Street, are next-door neighbors who visit each other daily. Here they are celebrating Christmas in 1995 at Levia's house. Ed, a caring and compassionate person, watches out for his neighbors and takes an interest in their lives. Levia was born in 1904, in the town of Baden that was later incorporated into South San Francisco. She attended school on Mission Road with her two brothers, the Coruccini Brothers, who were well-known contractors that built many homes in South San Francisco. (Courtesy of South San Francisco Historical Society.)

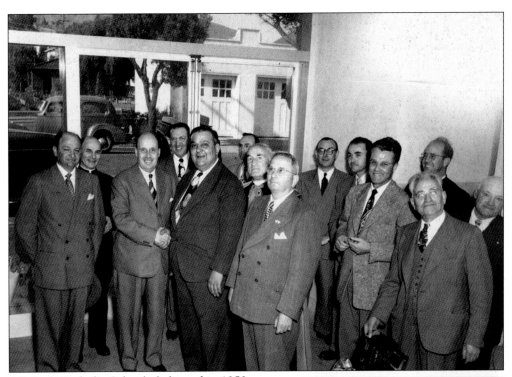

All Souls Catholic School, dedicated in 1950, was South San Francisco's first Catholic school. Pictured, from left to right, are town dignitaries (front row) Joseph Bracco (councilmember), unidentified, Adolph Sani (mayor), and Emilio Cortesi (councilmember), and James Spuri; (back row) clergy, RobertRoccucci, Ernie Bonalanza, Monsignor Egisto Tozzi, John "Jiggs" Bonalanza (city treasurer), Guido Rozzi (councilmember), Herb Schaunm, Fr. Varni, and John Tacchi. In September, the first students were admitted and greeted by the principal, Sister Mary Victoria, and her staff of Immaculate Heart of Mary Sisters. (Courtesy of South San Francisco Historical Society.)

Congressman Leo J. Ryan served on the city council from 1956 to 1963, served as mayor in 1962, and was elected to the U.S. Congress in 1963. The congressman met a tragic death on November 18, 1978, while on a fact-finding and rescue mission to Jonestown, Guyana. Ryan was described as a great man continuously exceeding his constituents' expectations. (Courtesy of South San Francisco Historical Society.)

Councilwoman Roberta Teglia is giving the oath of office to City Treasurer Beverly Bonalanza Ford. Roberta Teglia was the city's first councilwoman (1978–1995) and served as mayor four times. Beverly Ford was the city's fourth city treasurer (1986–2003), succeeding her father, Jiggs Bonalanza. Roberta and Beverly were lifelong friends. (Courtesy of John Wong.)

Bob Yee was the first Asian councilmember and served as mayor in 1995. He is seen hosting a sister city student delegation from Kishiwada in 1995. The picture was taken in city council's office at city hall. South San Francisco has four sister cities—Lucca, Italy; Atotonilco, Mexico; Kishiwada, Japan; and Pasig City, Philippines. The program was organized in 1976 to foster cultural, educational, and social exchanges. Prior to serving on council, Bob Yee was the city engineer, director of public works and retired as deputy city manager in 1991. (Courtesy of John Wong.)

The historical society holds a Victorian tea at the Plymire Schwarz House and Fire Museum, 519 Grand Avenue as annual fundraiser for the home. Pictured are the hard-working members in the kitchen, from left to right, (front row) Kay Staphopolos, Valerie Carley, Mary Giusti, Phyllis Feudale, Rose Bava, Sylvia Payne, Louise Brusco, and Jo Zemke; (back row) David Casagrande, Margie Casagrande, Evelyn Casagrande, Bill Zemke, Barbara Crossland, and Roy Bava. Margarete Schwarz deeded the home to the society in 1994 to display her husband's artwork for the public's enjoyment. (Courtesy of Roy Bava.)

Jack Drago, former mayor and founder of the cultural arts commission, envisioned the use of public art in prominent areas for residents to appreciate. The park on East Grand Avenue at Gateway Boulevard, once an industrial site, is dedicated in his honor and was celebrated on April 27, 1997. The East Grand Avenue landscape theme of using large boulders in the design was implemented at key entrances with the intention of creating a recognizable signature for the city. Pictured, from left to right, are Al Teglia (former Daly City mayor), Dag Alholm, Lola Garcia, Lee DaPrato, Ann Garbero, Evelyn Martin, and Jack Drago. (Courtesy of John Wong.)

Historical society members Alice (Uccelli) Marsili (left) and Eleonore Fourie (right) are eagerly selling raffle tickets at the annual historical society dinner in 1998. Born and raised in South San Francisco, they were instrumental in organizing the society and both served as president. Eleonore still volunteers a tremendous amount of her time to the Magnolia Museum as co-curator and sits on the Plymire Schwarz Steering Committee. (Courtesy of South San Francisco Historical Society.)

The historical society seal, drawn by Dorothy Bartell, was created shortly after the society was incorporated in 1980. It depicts the symbols of South San Francisco—the Iris, Sign Hill, and City Hall. The seal is also used on the society's membership pin and stationery. Dorothy was the editor of the Society's newsletter *Echoes* for more than 20 years, producing 81 issues. The coloring book "Once Upon A Time" was also her creation for children to learn South San Francisco's history in a fun and interesting way. (Courtesy of South San Francisco Historical Society.)

Standing at the front door of the Plymire Schwarz House is Victor (Johnny) Feudale with Councilman Joe Fernekes. The occasion was the grand opening of the museum on October 4, 1997. As a very active member of the historical society, Feudale worked tirelessly at the Plymire Schwarz House, making improvements and raising money to help finance the work. He served as society president for four years and was recognized as person of the year in 1993. The award is now called the Victor John Feudale Award. (Courtesy of South San Francisco Historical Society.)

Six

TRANSFORMATION TO
BIOTECH CITY

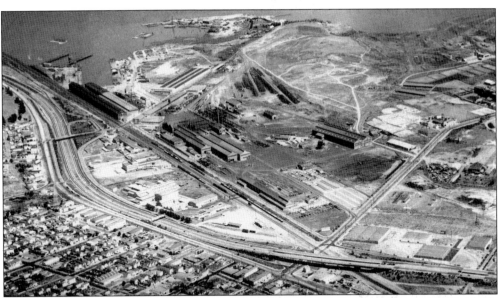

Pacific Coast Steel (established in 1911), a subsidiary of Metal & Thermit Corp (1920–1961), was the best-equipped steel works in the West, with a new six-mill plant built by D.P. Doak in 1924. Bethlehem Steele (a.k.a. Pacific Jupitor Steel Company) purchased the operation in 1930. Billets of steel were reheated before rolling into other forms such as structural I-beams and reinforcement rebars. This c. 1954 aerial view shows the enormous amount of land Bethlehem Steel possessed; by 1962 steel making had ceased at the facility. Deindustrialization began. Boston-based developer Cabot, Cabot, and Forbes built a light industrial park out on the Point in the mid-1960s. Warehouses and light manufacturing poured in. Traditional industry just as quickly took flight. (Courtesy of South San Francisco Public Library Local History Collection.)

The Southern Pacific Railroad tracks and Bayshore freeway clearly delineate the industrial area on the east side of the freeway from the residential area. The United States Steel site closed down in 1983. This land was heavily contaminated and went through several redevelopment proposals (the area was designated blighted), a bankruptcy by Shearwater Development, and several other ownerships before development began in 2000 by Slough Development. (Courtesy of South San Francisco Public Library Local History Collection.)

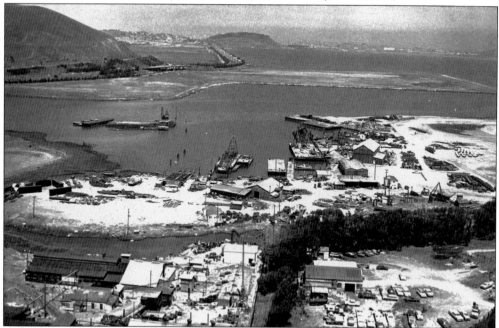

This 1972 aerial of the Oyster Point Boulevard area overlooks Healy Tibbits Construction Company (1941–1981) landfill work at Oyster Point; the area was developed into an office park and private marina in the 1980s. Facing north is Brisbane's undeveloped (landfill) Sierra Point area, San Bruno Mountain is to the left, and Bayshore Freeway (Highway 101) leads to San Francisco. (Courtesy of South San Francisco Public Library Local History Collection.)

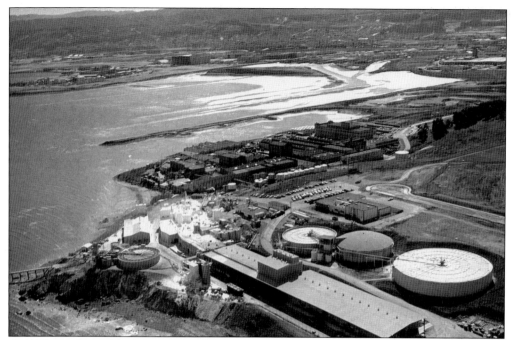

A 1970 aerial view, looking south, of Point San Bruno shows Merck and Company and Fuller Paint Company. Along with the transformation came the modernization of existing plants. (Courtesy of South San Francisco Public Library Local History Collection.)

Modernization from heavy industry to warehousing during the 1950s is shown here by the newly completed H.D. Lee Company plant. Lee manufactured and distributed men's work clothes to seven Western states. (Courtesy of South San Francisco Public Library Local History Collection.)

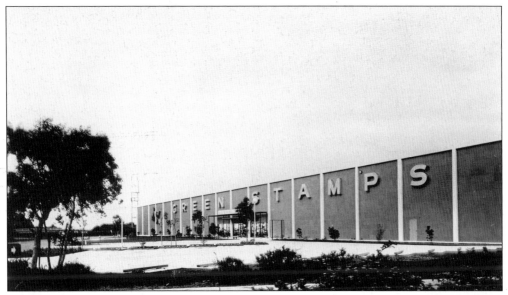

As the heavy industrial area started melting away, businesses such as Sperry & Hutchison Company (S&H Green Trading Stamps) were locating along Oyster Point Boulevard. S&H was in operation from 1958 to 1965 at 940 Dubuque Avenue. Various merchants issued the stamps that were pasted into booklets, which were cashed in for toasters, basketballs, and other merchandise. Levitz Furniture bought the building in the 1970s and presently operates at this location. (Courtesy of South San Francisco Public Library Local History Collection.)

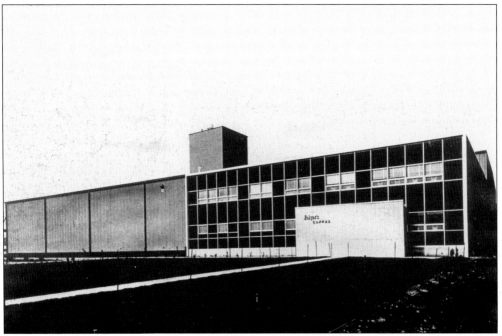

Folger's Coffee Company's processing plant, built in 1961, sent the aroma of roasting coffee into the air and through nearby businesses as it would waft across the bay. The plant operated in South San Francisco until 1994 at Littlefield and Harbor and closed due to company downsizing. (Courtesy of South San Francisco Public Library Local History Collection.)

Along with transformation and modernization came relocation. Pacific Telephone & Telegraph's offices opened in 1929–1941 at 226 Grand Avenue, operated during 1945–1954 at 234 Grand Avenue and during 1954–1982 at 226 Miller Avenue, and then a more modern facility was built in 1982 at its present location, 1487 Huntington Avenue. The city's first telephone company, Sunset Telephone and Telegraph Company, started in 1892 and operated out of the post office at San Bruno Road and Miller Avenue. (Courtesy of South San Francisco Public Library Local History Collection.)

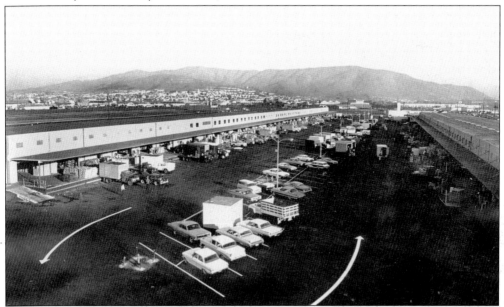

Thanks to redevelopment in San Francisco's produce area, Golden Gate Produce Terminal moved to South San Francisco in 1962 to a brand new facility at Terminal Court. A local author, Michael Milani, produced the book *It Happens Every Morning*, which chronicles the produce industry and the early hours that lumpers and truck drivers keep. The operation is ideally located next to the entrance to the freeway and only a few minutes from the airport. (Courtesy of South San Francisco Public Library Local History Collection.)

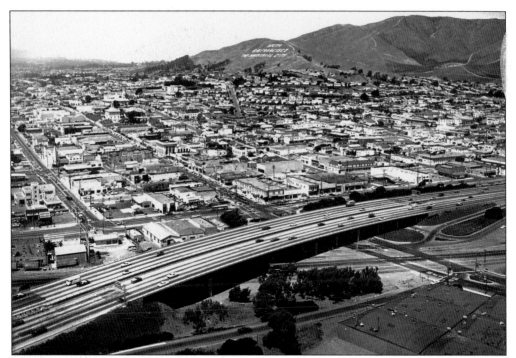

Highway 101 diverted traffic from city streets and separated the industrial area from the residential/commercial area of the downtown. The evolution of South San Francisco was directed towards a balanced community with the desirability as both a place to live and to work. (Courtesy of the South San Francisco Public Library Local History Collection.)

With the development of biotech, hospitality, and research and development industries along the bay front, environmental agencies—concerned that the water's edge was no longer accessible—implemented laws to ensure that the natural shoreline would be preserved. Thus, the development of the bay access trails that occupy the first 200 feet of land closest to the water's edge. This attractive trail is for workers exercising during their breaks, but also for the residents to enjoy the beauty of the shoreline. (Courtesy of South San Francisco Historical Society.)

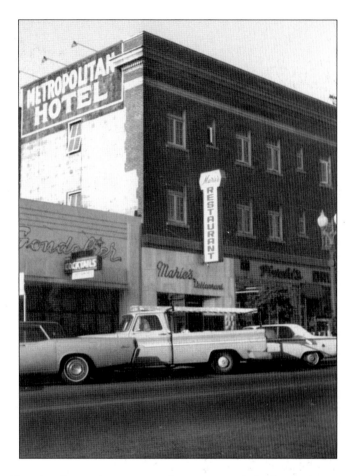

While the simple family-owned hotels of Grand Avenue and Airport Boulevard were being transformed into single-room occupancy hotels (e.g. Metropolitan Hotel), the "East of 101" area responded to the need for hotels to accommodate business visitors seeking an affordable rate for an extended stay by creating hotels such as these on Veterans Boulevard. More than 10 business hotels are now located in the East of 101. This desirable bayfront area is the inlet where the *Isanti* and *Nantohala* were launched during World War I and the Army/Navy C-3 ransports during World War II. (Courtesy of South San Francisco Historical Society.)

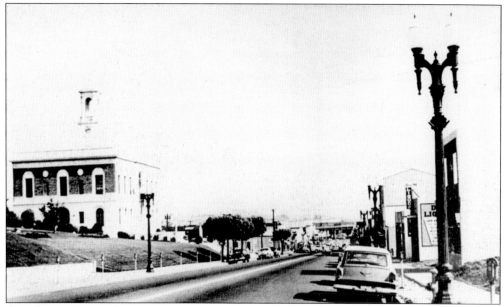

Grand Avenue was also experiencing a transition in this 1957 photo. Traditional parades were no longer occurring. Clothing stores, grocery stores, and meat markets went out of business and malls became the place to shop. But even with the storefronts changes, Grand Avenue was still maintaining a small-town feeling. (Courtesy of the South San Francisco Public Library Local History Collection.)

City Hall was built in 1920 and has gone through a series of interior renovations, including seismic retrofitting after the 1989 Loma Prieta earthquake. A seismic strengthening project was undertaken from 1998 to 1999 for this unreinforced masonry building that involved a core drilling system on the perimeter walls and exterior buttresses to brace the building. A rededication was held on May 26, 1999, and a ribbon-cutting ceremony was conducted by, from left to right, councilmembers Gene Mullin, Karyl Matsumoto, and James Datzman; chamber of commerce president Elaine Burrell; and councilmember Joe Fernekes. (Courtesy of John Wong.)

In 1984 the South San Francisco General Hospital (Kaiser) at 500 Grand Avenue was demolished and Kaiser built a new facility at 1200 El Camino Real. Several years later a controversial office building was constructed at this location that did not conform to the downtown architecture. It was the topic of much discussion at city hall until the Cultural Arts Commission had the "Whimsical Windows" installed to detract from the buildings odd façade. (Courtesy of South San Francisco Public Library Local History Collection.)

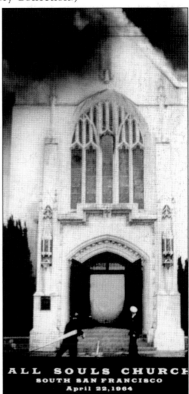

ALL SOULS CHURCH
SOUTH SAN FRANCISCO
April 22, 1964

On December 16, 1916, Archbishop Edward Hanna dedicated All Souls Church, located at Walnut and Miller Avenues, and built at a cost of $26,000. On April 22, 1964, this Gothic Tudor structure was completely destroyed by fire. It was a sad event that devastated the community and brought great architectural change to the downtown area. Msgr. Eugene Gallagher set a course to have a new church built at a cost of over $1 million. On February 16, 1969, a state-of-the-art Romanesque-style building was dedicated that parishioners found quite unique. In 1982, the South San Francisco Historical Society moved the "Sidewalk of Names" to the 500 block of Miller Avenue from California and Linden Avenues in honor of the pioneers who had the sidewalk paved at the original All Souls Church in 1911. (Courtesy of South San Francisco Historical Society.)

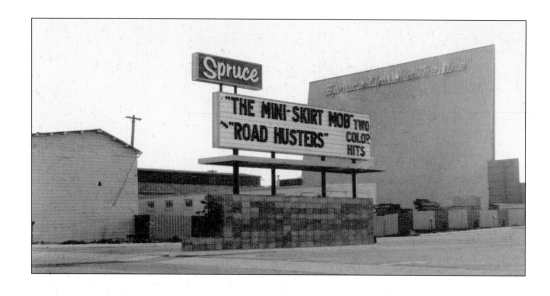

Shown here in 1968, the Spruce Avenue Drive-In, 55 South Spruce, was constructed in 1948. After World War II, housing construction exploded and pressure was put on the community to supply entertainment and recreation services for residents. The San Francisco Theater Corporation obtained 14 acres of flat land along the present Spruce Avenue, built a large screen, a parking area to accommodate 850 automobiles and with individual volume controlled speakers, and a snack bar. It was an inexpensive evening, 50¢ per automobile that let mom, dad, and the children out for the evening without the expense of a babysitter. The Spruce Drive-in closed in 1987 to make way for a office-warehouse development. Other drive-ins in the community were the Starlite (closed in the mid-1950s) and El Rancho (closed in 1979). (Courtesy of South San Francisco Public Library Local History Collection.)

Even in the middle of the 1980s a touch of the rural area still existed. The land at the west end of Grand Avenue at Oak, still owned by the Uccelli family, was a much sought after piece of land desperately wanted by developers. The Red Barn, at the center of the top photo and pictured below, was demolished in 2001 to make room for the Oak Farm residential development. (Courtesy of South San Francisco Public Library Local History Collection.)

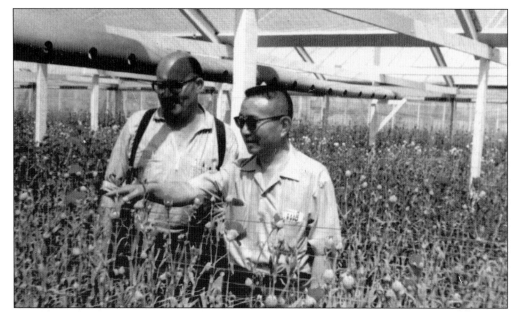

The Mazzanti Nursery and greenhouses, owned by Pete and Enis Mazzanti, were located off Tennis Drive to the rear of Orange Memorial Park. It began operation in the 1950s and closed down in 1999. The property was sold to the city for the future expansion of the park. Pete was active in the community and known for his prize-winning carnations. (Courtesy of South San Francisco Historical Society.)

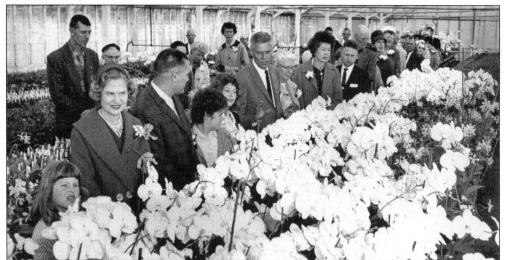

"Acres of Orchids" was the popular phrase that everyone knew meant Rod McLellan Nursery. The unincorporated area along El Camino Real was the location of the nursery when it moved here from Burlingame in 1926. Little by little its 61 acres were annexed into South San Francisco and developed for various needs, including Kaiser Hospital at 1200 El Camino Real. The last acreage was annexed in 1998 for a housing development, and the commercial orchid greenhouses were relocated to Watsonville. The international flavor of the city was enhanced in the 1950s by the visit of H.R.H. Queen Ingrid of Denmark and representatives of the state department to the world-renowned orchid farm. (Courtesy of South San Francisco Public Library Local History Collection.)

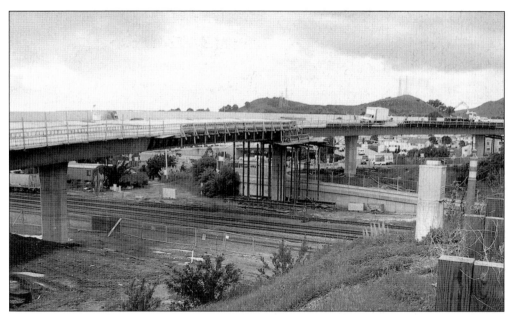

The Oyster Point flyover, a multi-million-dollar project, was built to enhance access to the East of 101 area for employees driving south on the Bayshore Highway from San Francisco. This 1993 flyover goes over the Caltrain tracks, another means of transporting employees to work in the East of 101 area. (Courtesy of Mike Lappen.)

From left to right, councilmember Joe Fernekes, Genentech representative Peter Yee (former Foster City councilmember), and Michael Giungona (former Daly City councilmember) attend the 1998 groundbreaking ceremonies for the Oyster Point flyover. The flyover, a multi-million-dollar project, is to move commuters quickly and safely off the freeway and directly into the East of 101 area. Genentech worked closely with the City and CalTrans for the successful completion of the project. (Courtesy of John Wong.)

Long before there was curbside pickup for recyclables, there was the city's recycling center on the 500 block of North Canal Street (in 1999, the South San Francisco Scavenger Company built a huge modern recycling facility on Haskins Way). The city kept its eyes on this North Canal property for quite a few years before it was developed into a new corporation yard dedicated on April 23, 1998. Also in the same area was the Guy F. Atkinson building, 10 West Orange Avenue, which was demolished in 1994 and replaced by the Parc Place housing development in 2000. (Courtesy of John Wong.)

As with any landmark, a city can provide identification for an entrance to a specific area. With this sign on the main corridor into the biotech neighborhood, placed on a median along Oyster Point Boulevard, one knows exactly that one has entered into South San Francisco's world-renowned home of biotechnology. (Courtesy of Genentech, Inc.)

Genentech was founded in 1976 by Robert Swanson and Herbert Boyer in a semi-vacant warehouse and became the world's first biotech company. The city's strategic location helped it become the world center for bioscience. Today Genentech is one of the city's most community active and generous companies. It employs over 4,500 people and continues to expand its employee base and campus. (Courtesy of Genentech, Inc.)

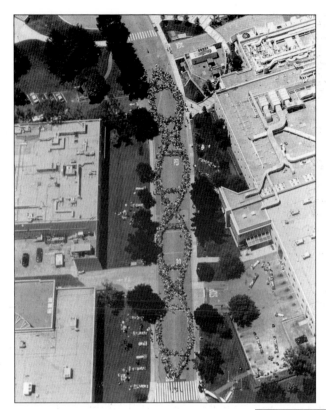

On June 27, 1997, Genentech employees gathered along DNA Way and formed a human helix. Genentech leads by example of employee and public relations. There is a strong chamber of commerce and community presence that has enhanced both the company and the city. (Courtesy of Genentech, Inc.)

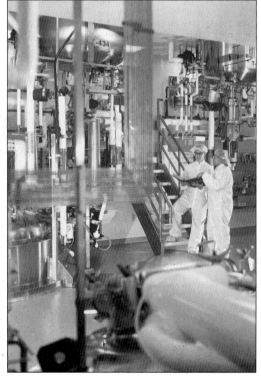

Here are Genentech employees discussing a project next to the 2,000-liter fermentation tank. Genentech's 450 scientists are at the top of their field and are working on numerous pharmaceutical projects for the company to develop, manufacture, and market that will address significant unmet medical needs. (Courtesy of Genentech, Inc.)

Childcare is a 21st-century issue. The convenience of a center near a worksite is good for the employee and good for the employer. Under construction on Gateway Boulevard is this center that will address the needs of employees in the East of 101 area, but these types of buildings are always a concern on industrial sites that can be contaminated and remediation work can be costly. This center will be operated by the YMCA. (Courtesy of Mike Lappen.)

The South San Francisco Conference Center site (255 South Airport Boulevard) was formerly a photo processing plant that was renovated and opened in April 1993. It has a glass-encased, four-story atrium lobby with a dramatic free-form floating ceiling. The center was built as a response to a concern that South San Francisco had a lack of meeting space in its hotels and was losing business to other towns on the Peninsula. The center has been very successful and efforts to have it expanded remain a focus for the city. (Courtesy of South San Francisco Historical Society.)

The Millennium sculpture was dedicated on November 5, 1999, and is at the city's entrance at Westborough Boulevard and Junipero Serra. It was selected by the Cultural Arts Commission after a national competition was held. Sculpted by James T. Russell, the sculpture demonstrates the city's pride in the community and a commitment to enhance its quality of life. Mr. Russell commented, "the sculpture mirrors the city's movement into the 21st century, from its beginnings in industry, through vision and dedication, with guided technologies and efforts, to a beautiful, shinning presence, and even brighter future." (Courtesy of John Wong.)